日本風景写真協会

俳句の風景

Photographs of Imagined
HAIKU
Landscapes

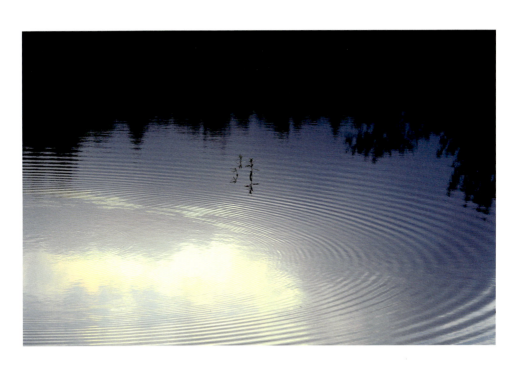

光村推古書院

Photographs of Imagined HAIKU Landscapes

First Edition December 2018
by Mitsumura Suiko Shoin Publishing Co.,Ltd.
217-2 Hashiura-cho Horikawa Sanjo
Nakagyo-ku, Kyoto 604-8257 Japan

Photographer: Members of Japan Nature Scenery Photograph Association
Composer: OCHII Shunichi
Executive Chairman: OHTO Toshiyuki, DEAI Noriko, YAMAGUCHI Kazumi
Translator: SASADA Keiko
Editor: GODA Yusaku
Coordinator: YAMAMOTO Takahiro
Designer: MATSUDA Satoko
Publisher: GODA Yusaku

©2018 Japan Nature Scenery Photograph Association Printed in Japan

All Rights reserved. No Part of this publication may be reproduced or used
in any form or by any means, graphic, electronic, or mechanical, including
photocopying, recording, taping, or information storage and retrieval systems,
without written permission of the publisher.

ISBN978-4-8381-9839-9

表紙カバー写真
　おもて：中務敦行
　　うら：渡辺久子
扉：黄江康広
P.2：藤原昌平

凡例
本書は日本風景写真協会の会員が自由な発想のもと、俳句から想起される
イメージを写真に収めたものを俳句とともに掲載した写真集です。
俳句が詠まれた場所と写真を撮った場所が違う場合もあります。

風景写真家が俳句のイメージをとらえ、
日本の原風景とも呼べる世界をお届けします。

Capturing the image of *Haiku*,
Scenery photographers show you the world
that can be called "original landscapes of Japan."

梅一輪いちりんほどの暖かさ 嵐雪

one single plum
coming out
slightly warmer
Ransetsu

服部嵐雪（はっとり らんせつ）1654-1707
HATTORI Ransetsu

江戸時代中期の俳人。江戸生まれ。延宝三年（1675）頃に松尾芭蕉に入門したとされる。榎本其角とともに江戸蕉門の双璧と称えられた。『其袋』『若水』『つるいちご』などの俳書がある。

HATTORI Ransetsu, born in Edo (now Tokyo), was a *Haiku* poet in the middle period of the Edo era. It is said that he became a disciple of MATSUO Bashō in around 1675. He was praised, together with ENOMOTO Kikaku, as one of the great two poets of the disciples of Bashō in Edo. Ransetsu wrote books for *Haiku* such as "Sonofukuro," "Wakamizu," and "Tsuruichigo."

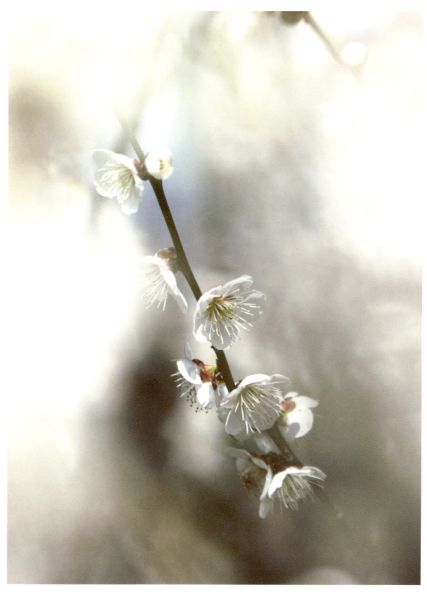

神奈川県湯河原町幕山公園　Kanagawa Pref.　　　　　　　中島修一

紅梅の
　蕾は固し
言はず

虚子

firmly closed
buds of red ume blossoms
say nothing

Kyoshi

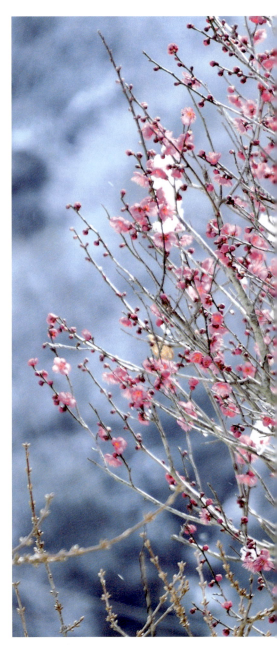

高浜虚子（たかはま きょし）1874-1959
TAKAHAMA Kyoshi

松山で生まれ、明治から昭和にかけて俳句と小説で活躍した。正岡子規と関わりをもつことで俳句の道に進み、子規亡き後、雑誌「ホトトギス」を継承し、発展させた。昭和29年（1954）、文化勲章を受章した。

TAKAHAMA Kyoshi, born in Matsuyama, was actively involved in the field of *Haiku* and novel from the Meiji era to the Showa era. He had a relationship with Masaoka Shiki to start a carrier as a *haiku* poet. After the death of Shiki, Kyoshi succeeded a *Haiku* magazine "Hototogisu" and contributed to its development. In 1954, Kyoshi was awarded the Order of Culture.

岡山県高梁市　　Okayama Pref.

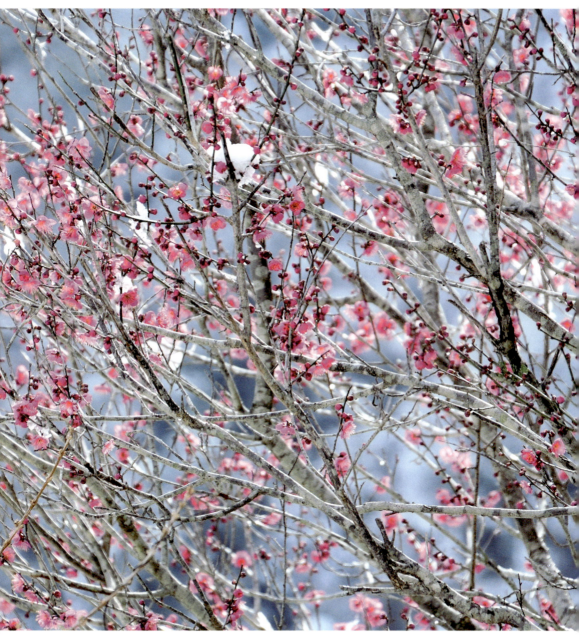

黄江康広

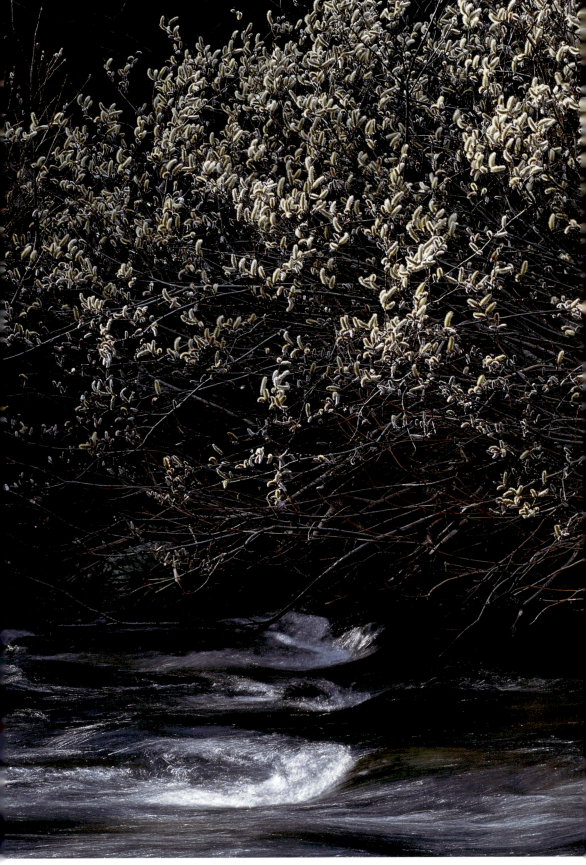

和歌山県新宮市西高田　　Wakayama Pref.　　　　　山本 一

西山泊雲 (にしやま はくうん)　1877-1944
NISHIYAMA Hakuun

兵庫県に生まれる。明治から昭和にかけて雑誌「ホトトギス」で活躍した俳人。実弟の野村泊月も俳人として知られる。

NISHIYAMA Hakuun was born in Hyogo prefecture. He was a *Haiku* poet actively involved in a *Haiku* magazine "Hototogisu" from the Meiji era to the Showa era. His brother, NOMURA Hakugetsu, is known as a *Haiku* poet, too.

早春の
流水早し
猫柳

泊雲

early spring,

water is running earlier

under pussy willows

Hakuun

春いまだ
田毎の雪間々々かな
白雄

spring can be seen
still only from cracks in snow
in each rice field

Shirao

加舎白雄（かや しらお）　1738-91
KAYA Shirao

江戸時代中期の俳人。俳論の書『加佐里那止（かざりなし）』『春秋稿』などの著作を遺した。私意や技巧に頼らず、平明で自然であることを旨とし、当時の俳壇で大きな影響力があった。

KAYA Shirao was a *Haiku* poet in the middle period of the Edo era. He wrote books for *Haiku* theory such as "Kazarinashi" and "Shunjūkō." His style is being clear and natural not depending on self-interests and techniques, having a great influence on the *Haiku* community at that time.

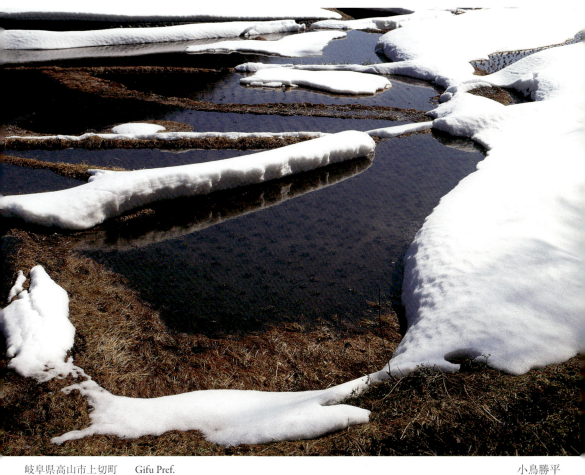

岐阜県高山市上切町　Gifu Pref.　　　　　　　　　　　　　　　　　　　　　小鳥勝平

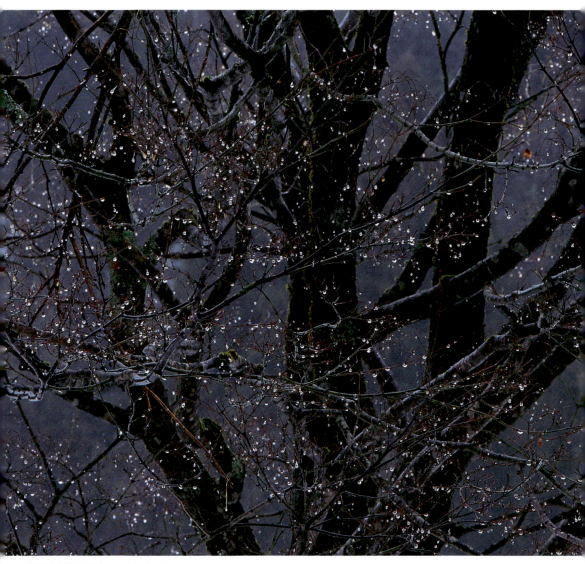

滋賀県高島市朽木　　Shiga Pref.

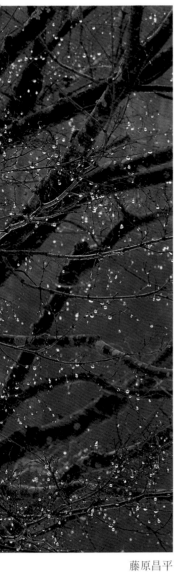

藤原昌平

枯枝に
初春の雨
玉圓か

虚子

early spring rain drops
falling down on dead branches
like circular coins

Kyoshi

高浜虚子（たかはま きょし）1874-1959
TAKAHAMA Kyoshi
（p.6参照）

野を焼くや
棚曇りして
二三日

花蓑

after burning the field
clouds have blanketed the sky
for a few days

Hanamino

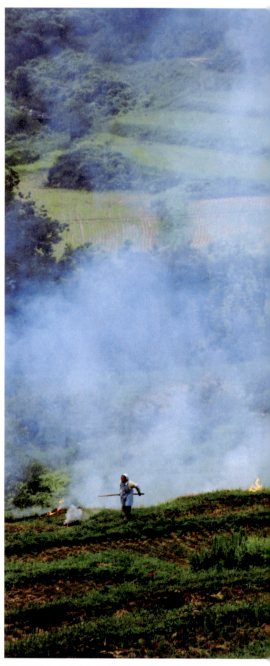

鈴木花蓑（すずき はなみの） 1881-1941
SUZUKI Hanamino

大正から昭和にかけて活躍した俳人。愛知県に生まれる。高浜虚子の唱える「客観写生」の真髄を理解し、具現したといわれる。

SUZUKI Hanamino, born in Aichi prefecture, was a *Haiku* poet who was active from the Taisho era to the Showa era. It is said that Hanamino understood and realized the essence of "Kyakkan Shasei (objective portrayal)" advocated by TAKAHAMA Kyoshi.

千葉県鴨川市大山千枚田　　Chiba Pref.

中村隆是

宮城県名取市閖上　　Miyagi Pref.

前田普羅（まえだ ふら）　1886-1951
MAEDA Fura

大正から昭和にかけて活躍した俳人。早稲田大学を退学後、幾度かの職を経て、新聞記者となった。飯田蛇笏、村上鬼城、原石鼎らと雑誌「ホトトギス」を代表する俳人として知られた。

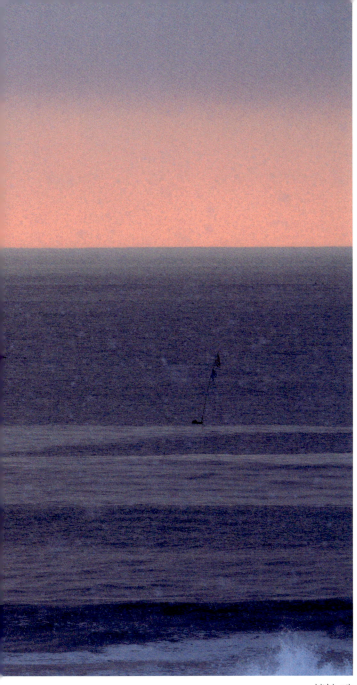

春雪の
しばらく降るや
海の上

普羅

spring snow-
it is snowing for a while
on the sea

Fura

植村 功

MAEDA Fura was a *Haiku* poet who was active from the Taisho era to the Showa era. After leaving Waseda University and changing several jobs, he became a newspaper reporter. Fura was a known poet, together with IIDA Dakotsu, MURAKAMI Kijō, and HARA Sekitei, in a *Haiku* magazine "Hototogisu."

湖青し
雪の山々
鳥帰る
子規

over the blue lake, and
snowy mountains
birds are going back

Shiki

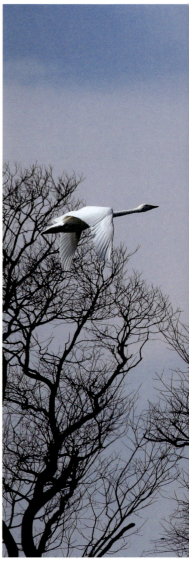

滋賀県長浜市湖北町　　Shiga Pref.

正岡子規（まさおか しき）　1867-1902
MASAOKA Shiki

明治時代の俳人、歌人。江戸時代末期、現在の松山市に生まれる。大学予備門入学試験に合格後、上京し、和歌や俳句をつくるようになった。柳原極堂は雑誌「ホトトギス」を創刊し子規を支援、のちに子規が東京に引き取り全面的に「ホトトギス」刊行に尽力した。

MASAOKA Shiki was a *Haiku* poet and a poet in the Meiji period. He was born in Matsuyama at the end of the Edo era. After passing an entrance examination of a preparatory school, Shiki moved to Tokyo, and created traditional style Japanese poems (called Waka) and *Haiku* poems. Shiki was supported by YANAGIHARA Kyokudō who founded a *Haiku* magazine "Hototogisu" under Shiki's direction. Later, Shiki moved the magazine's operation to Tokyo, and made an effort to publish "Hototogisu."

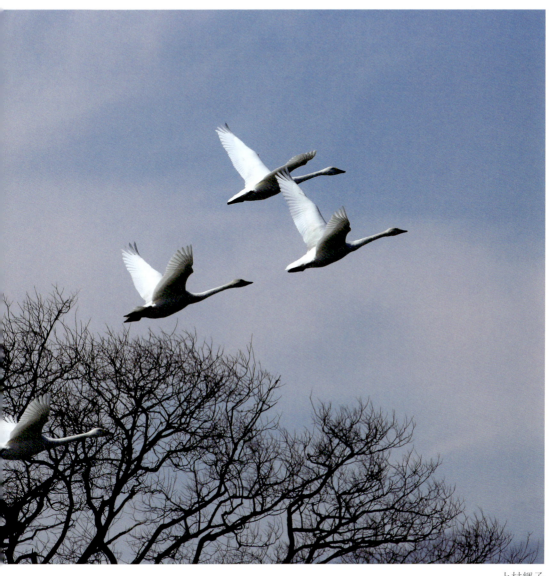

上村輝子

芽を吹きて
柳もつるる
こと多し

虚子

buds are shooting and
branches of willows are getting tangled
more and more

Kyoshi

高浜虚子（たかはま きょし）1874-1959
TAKAHAMA Kyoshi
（p.6 参照）

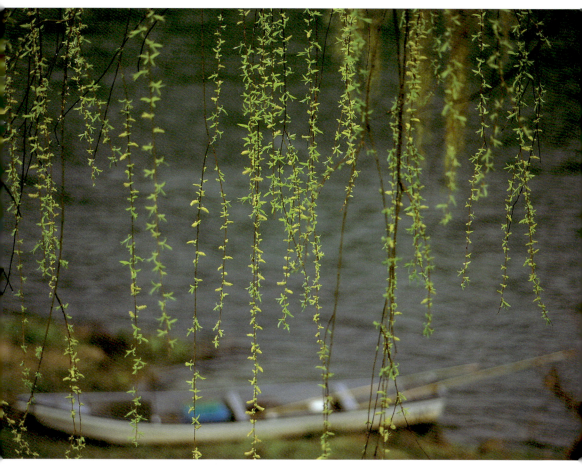

岡山県岡山市北区御津中牧　Okayama Pref.　　江田弘良

富士薄く
雲より上に
霞みたり
子規

haze Mount Fuji
can be seen
above the clouds
Shiki

山梨県山中湖村髙指山　Yamanashi Pref.

正岡子規（まさおか しき）1867-1902
MASAOKA Shiki
(p.18参照)

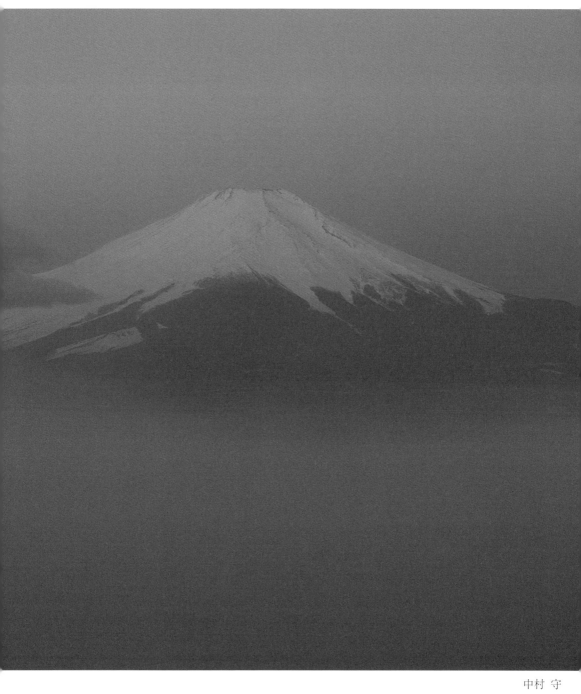

中村 守

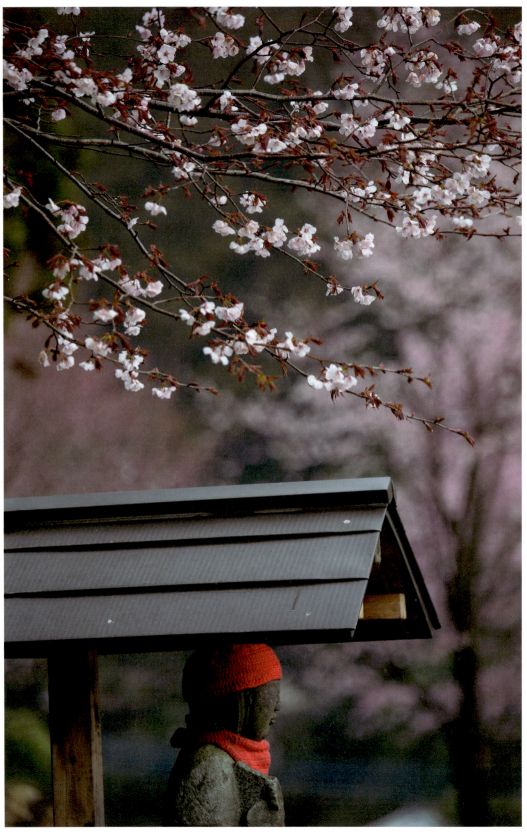

群馬県東吾妻郡岡崎榛名神社　　Gunma Pref.　　櫻井勝美

さまざまの事おもひ出す櫻かな

many, various memories
coming up with my mind
through cherry blossoms

Bashō

芭蕉

松尾芭蕉 (まつお ばしょう) 1644-94
MATSUO Bashō

伊賀上野に生まれる。29歳の頃、俳諧師として生きるため江戸に移り住み、北村季吟に師事したといわれる。桃青と号していたが、はせを・芭蕉とも署名した。『おくのほそ道』を著し、『猿蓑』を後見したりして、俳諧に偉大な足跡を遺した。

MATSUO Bashō was born in Iga Ueno. It is said that, at the age of around 29, he moved to Edo to make a living as a *Haiku* poet, and studied under Kitamura Kigin. He used "Tōsei" as a pen name and also signed as "Bashō (*haseo*)." Bashō wrote "Oku no Hosomichi" and promoted "Sarumino," and left behind a great achievement in *Haiku* poetry.

しばらくは
花の上なる
月夜かな
芭蕉

for a while,
the moon above a flower tree-
on a moonlight night

Bashō

京都府京都市　Kyoto Pref.

松尾芭蕉（まつお ばしょう）1644-94
MATSUO Bashō
（p.25 参照）

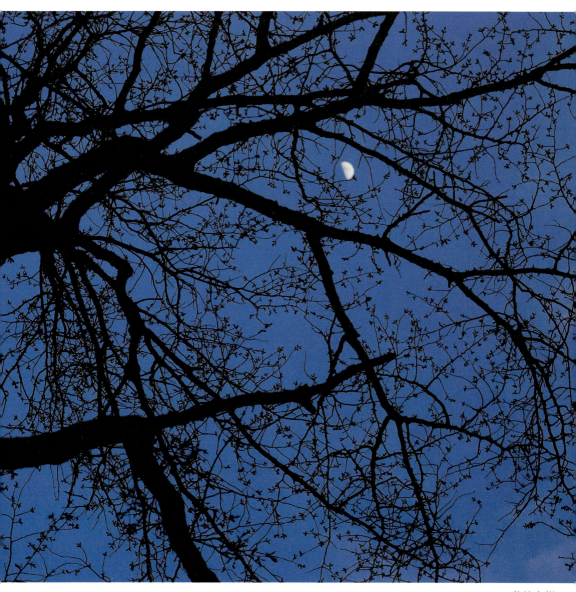

柴﨑久樹

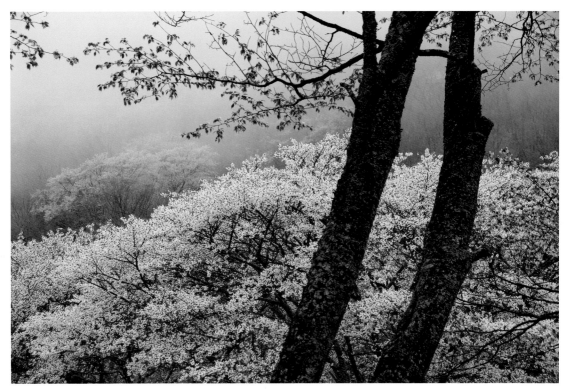

奈良県宇陀郡曽爾村　　Nara Pref.　　　　　　　　　　　　　　　　　　　　　　柏尾浩司

さびしさに
花さきぬめり
山ざくら

蕪村

for loneliness,
are the cherry blossoms blooming?
-on the mountain

Buson

与謝蕪村（よさ ぶそん）　1716-83
YOSA Buson

江戸時代中期の歌人。現在の大阪府に生まれる。20歳の頃、単身江戸へ出て俳諧や書画、漢詩文などを学んだといわれる。本姓は谷口で、丹後で三年半の間、画業に打ち込んだのち、与謝と名乗るようになった。

YOSA Buson, born in present Osaka prefecture, was a *Haiku* poet in the middle period of the Edo era. It is said that, at the age of around 20, Buson moved to Edo alone, and to study *Haiku*, painting, calligraphy, and Chinese poetry. His original family name is Taniguchi, and after having devoted himself to painting in Tango area for three and a half years, Buson called himself YOSA.

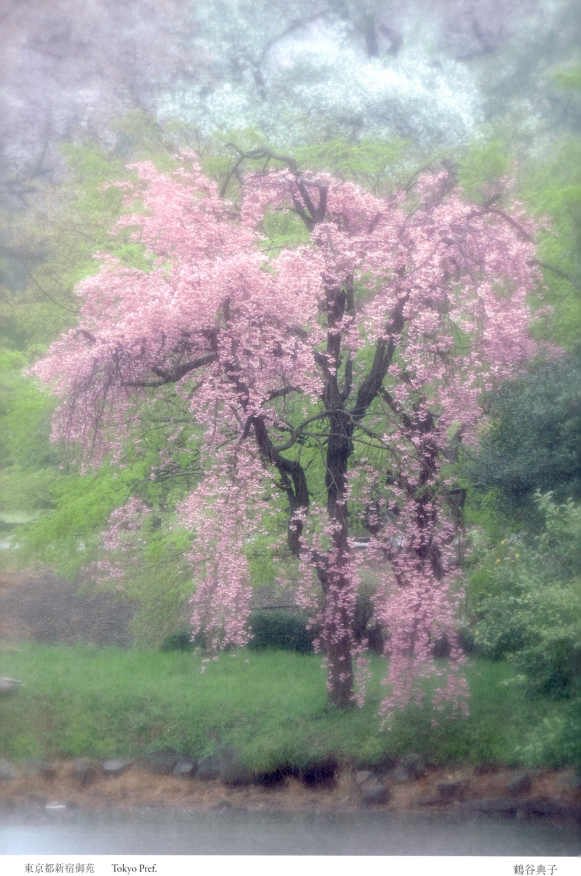

東京都新宿御苑　　Tokyo Pref.　　　　　　　　　　　　　　　　　　　　　鶴谷典子

加賀千代女（かがの ちよじょ）　1703-75
KAGA no Chiyojo

江戸時代中期の女流俳人。現在の石川県に生まれる。さまざまな伝説があり、その生涯は謎が多い。50歳を過ぎて剃髪し、千代尼と呼ばれた。

KAGA no Chiyojo, born in present Ishikawa Prefecture, was a female *Haiku* poet in the middle period of the Edo era. There are various legends about her, but her life is mysterious. She became a nun after she passed the age of 50, and was called "Chiyo Ama."

うつくしい
夢見直すや
花の春

千代女

as if the wonderful,
beautiful dream was again–
spring flowers

Chiyojo

下からも
見上げて居るや
花吹雪
　泊月

cherry blossoms falling
and lifted up in the wind-
flower drift

Hakugetsu

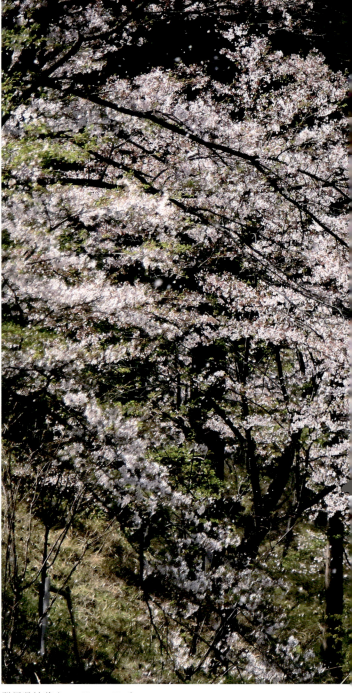

群馬県妙義山　　Gunma Pref.

野村泊月（のむら はくげつ）1882-1961
NOMURA Hakugetsu

兵庫県に生まれる。西山泊雲の実弟。結婚して野村姓となった。
早稲田大学在学中から高浜虚子に師事し、酒豪としても知られ、
関西俳壇で活躍した。

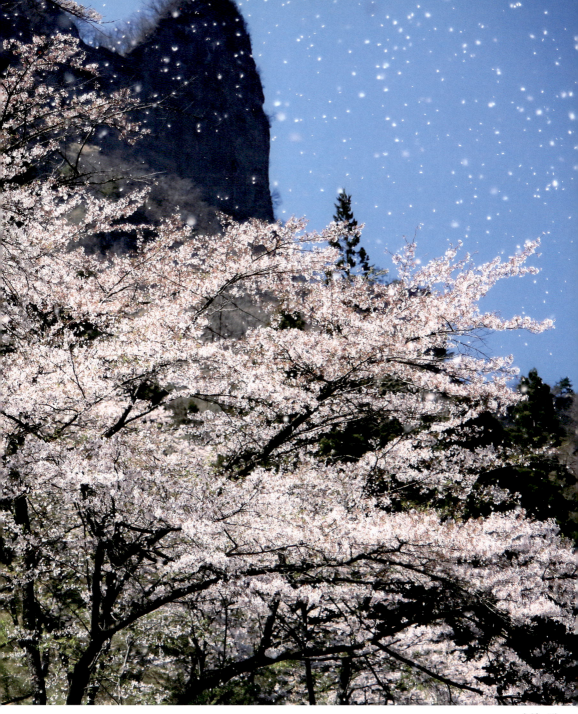

小池 測

NOMURA Hakugetsu was born in Hyogo prefecture. Hakugetsu was a brother of NISHIYAMA Hakuun, and changed his family name from NISHIYAMA to NOMURA after his marriage. He studied under TAKAHAMA Kyoshi when he was in Waseda University, and was also known as a hard drinker. He was actively involved in the community of *Haiku* in Kansai area.

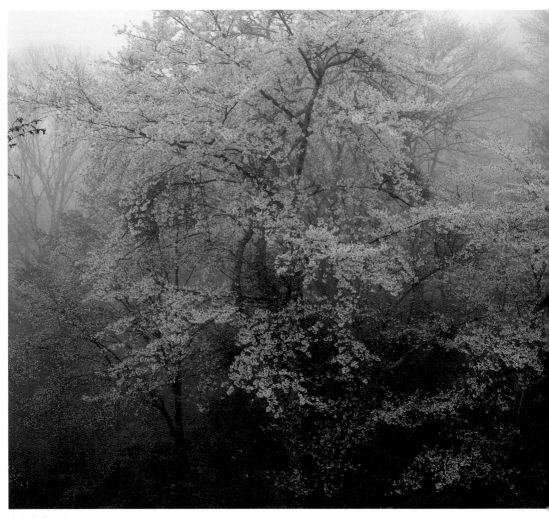

奈良県吉野山　Nara Pref.

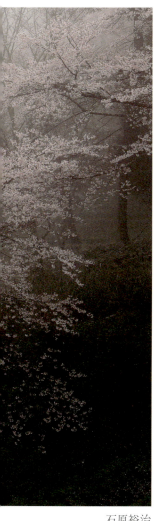

石原裕治

大峯や
よしのの奥の
花の果て

曾良

it is Ōmine
the farthest place of Yoshino
where flowers are blooming

Sora

河合曾良（かわい そら）　1649-1711
KAWAI Sora

江戸時代中期の俳人。現在の長野県に生まれる。成人後、江戸に出て和歌などを学んだのち、松尾芭蕉に入門した。『奥の細道』に随行し、旅中の日記や記録を『曾良旅日記』として著した。

KAWAI Sora, born in present Nagano prefecture, was a *Haiku* poet in the middle period of the Edo era. After he became of age, Sora moved to Edo to study traditional style Japanese poems (called Waka), and thereafter, became a disciple of MATUSO Bashō. Sora accompanied Bashō on Bashō's travel to the Northern Provinces (based on which "Oku no Hosomichi" was written), and wrote a diary or memorandum during the travel as "Travel Diary of Sora."

散る桜
残る桜も
散る桜

良寛

some cherry blossoms are falling,
the remaining ones are going to fall down,
too

Ryōkan

良寛 (りょうかん) ?-1831
Ryōkan

江戸時代後期の禅僧。現在の新潟県に生まれる。良寛の父親は加藤曉台に師事した俳人であった。詩歌にすぐれ、多くの和歌や詩を遺した。

Ryōkan, born in present Niigata prefecture, was a Zen Buddhist monk in the late period of the Edo era. His father was a *Haiku* poet studied under KATO Kyōtai. Ryōkan was excellent at poetry, and created lots of traditional style Japanese poems (called Waka) and poems.

新潟県南魚沼市巻機山　Niigata Pref.　　　　　　　　　　　　　　　　　　　橋本友男

苗代の
水田に昼の
雲動く

肋骨

on the field of a rice seeding bed,

reflected is

moving cloud in daytime

Rokkotsu

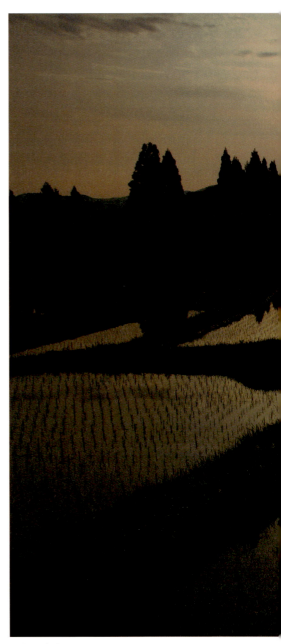

兵庫県香美町　　Hyogo Pref.

佐藤肋骨（さとう ろっこつ）　1871-1944
SATO Rokkotsu

明治から昭和にかけての俳人。軍人でもあり、陸軍少将を務めた。俳句は正岡子規の薫陶を受けた。

SATO Rokkotsu was a *Haiku* poet who was active from the Meiji era to the Showa era. He was also a military man, and served as a Major General. Educated by MASAOKA Shiki, Rokkotsu studied *Haiku*.

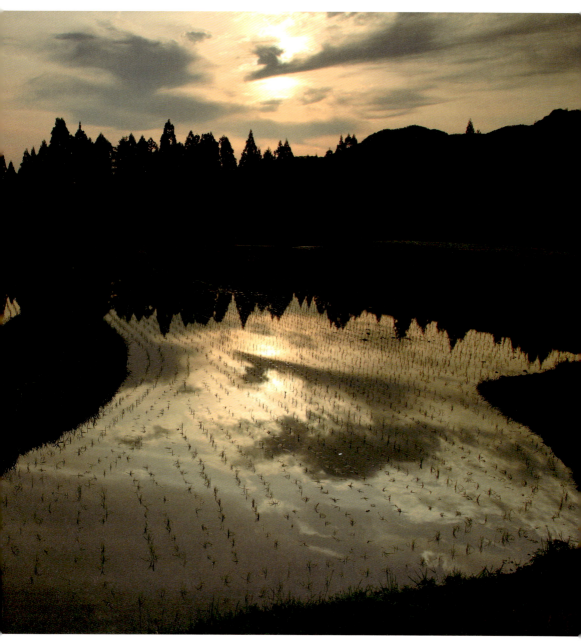

山本正二郎

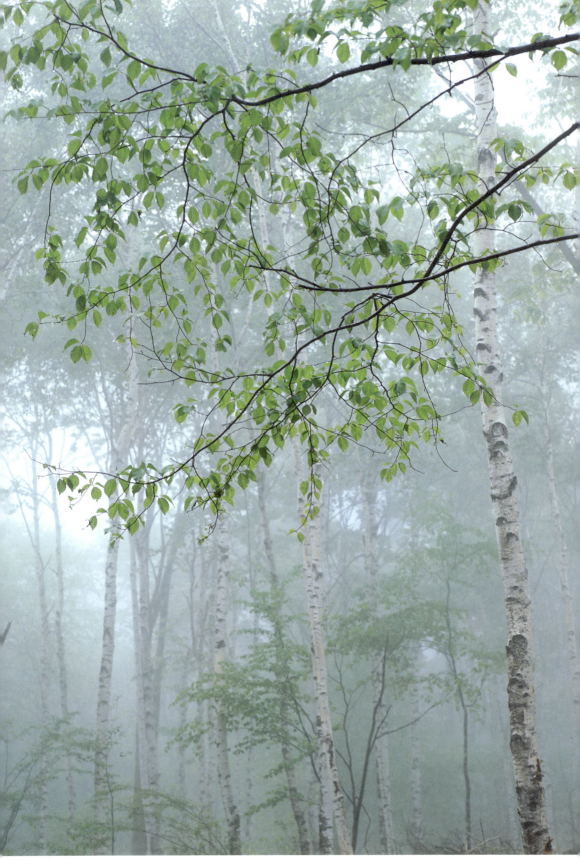

長野県佐久穂町　　Nagano Pref.　　　　　　　　　　　　勝又れい子

now clearly changed to
vivid young leaves
from pale dreams

TERADA Torahiko

まざまざと
夢の逃げゆく
若葉かな

寺田寅彦

寺田寅彦（てらだ とらひこ）　1878-1935
TERADA Torahiko

明治から昭和にかけて活躍した物理学者で随筆家。熊本の第五高校で夏目漱石に俳句を習う。東京帝国大学に入り、のちに教授となる。日常の世界に科学の眼を向けることに注力した。

TERADA Torahiko was a physicist and an essayist, and was active from the Meiji era to the Showa era. He studied *Haiku* under NATSUME Sōseki at the Fifth High School in Kumamoto. He entered Imperial University of Tokyo, and later, was appointed as a professor. Torahiko focused on grasping the ordinary world from a scientific point of view.

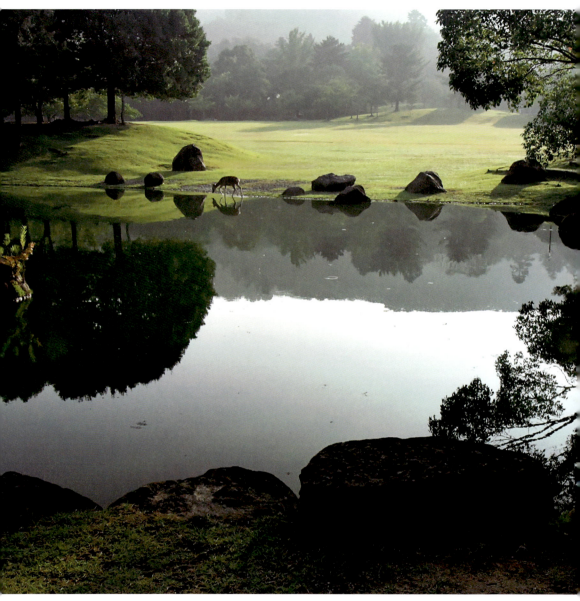

奈良県奈良公園　　Nara Pref.

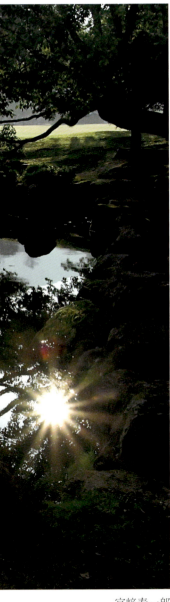

宮﨑寿一郎

春日野や
若紫の
そうがのこ

季吟

on Kasugano field,
little fawns
here and there

Kigin

北村季吟 (きたむら きぎん)　1624-1705
KITAMURA Kigin

江戸時代中期の歌人。近江に生まれる。16歳の頃から俳諧の手ほどきを受けた。多くの古典の講釈を行い、注釈書も著した。元禄の頃、幕府の歌学方として召され、神田に邸宅を賜り、江戸に移り住んだ。

KITAMURA Kigin, born in Ōmi, was a *Haiku* poet in the middle period of the Edo era. He started studying *Haiku* at his age of around 16. Kigin lectured on lots of classics, and wrote lots of annotations of the classics. In the Genroku period, he served as a poetry teacher in the Tokugawa feudal government, was given a house at Kanda, and moved to Edo.

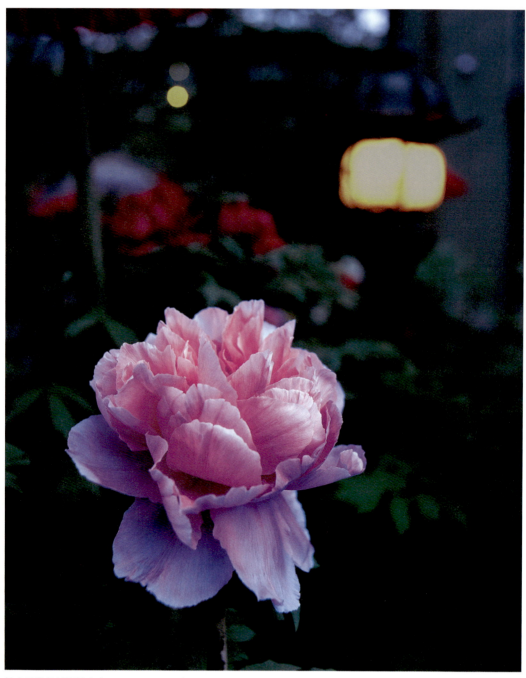

神奈川県松田町延命寺　　Kanagawa Pref.　　　　　　　　　　　　　　　　　　安藤和幸

戻りては
灯で見る庵の
ぼたんかな

千代女

back to the hermitage,
it is a peony that I am enjoying
with a right in the hermitage

Chiyojo

加賀千代女（かがの ちよじょ）　1703-75
KAGA no Chiyojo
(p.31参照)

心ここに
なきかなかぬか
　時鳥
　　井原西鶴

absent-mindedly

a cuckoo is wondering

whether he should warble or not

IHARA Saikaku

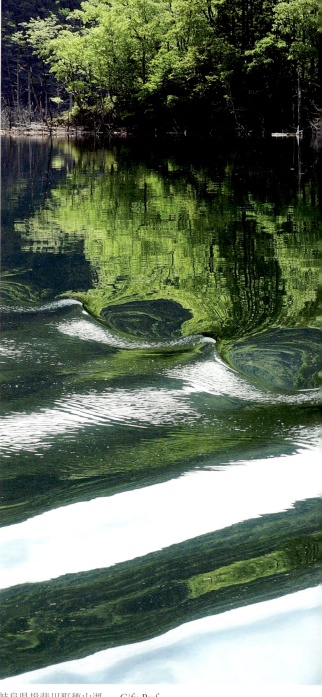

岐阜県揖斐川町徳山湖　　Gifu Pref.

井原西鶴（いはら さいかく）　1642-93
IHARA Saikaku

江戸時代前期の俳人、浮世草子作者。現在の大阪府に生まれる。
15歳の頃から俳諧を学んだといわれる。『好色一代男』は好評を
博し、以後も江戸の世相を切り取った作品を多く著した。

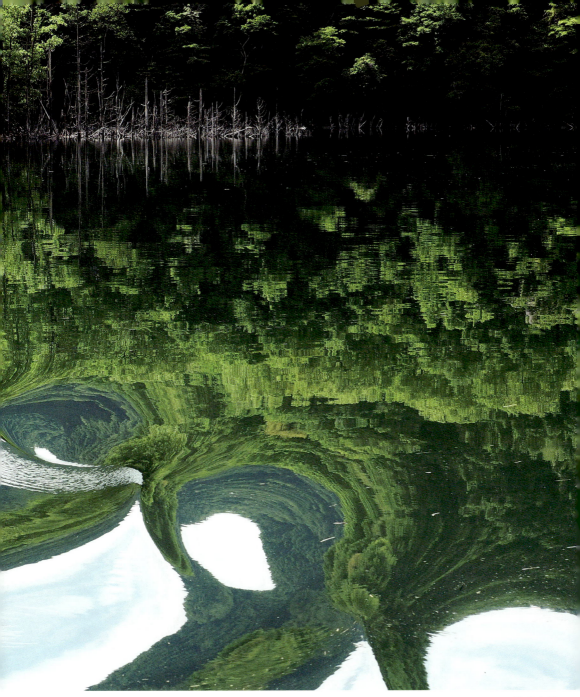

片島史朗

IHARA Saikaku, born in present Osaka prefecture, was a *Haiku* poet and a writer of Ukiyozōshi (a genre of popular Japanese fiction) in the early period of the Edo era. It is said that he started studying *Haiku* at his age of around 15. Saikaku wrote "Kōshokuichidaiotoko" which gained a good reputation, and since then, wrote many stories on which social conditions at that time were reflected.

をちこちに
瀑の音聞く
若ばかな

蕪村

here and there
as if splash sound is heard
surrounded by fresh green
in the mountain

Buson

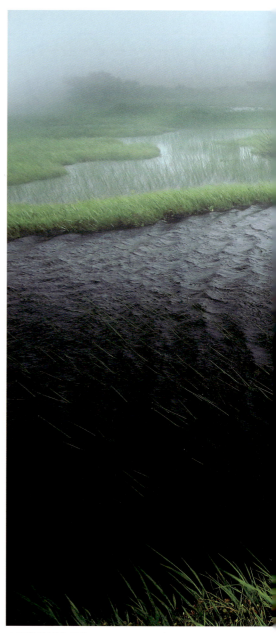

山形県鶴岡市月山　　Yamagata Pref.

与謝蕪村（よさ ぶそん）　1716-83
YOSA Buson
(p.29 参照)

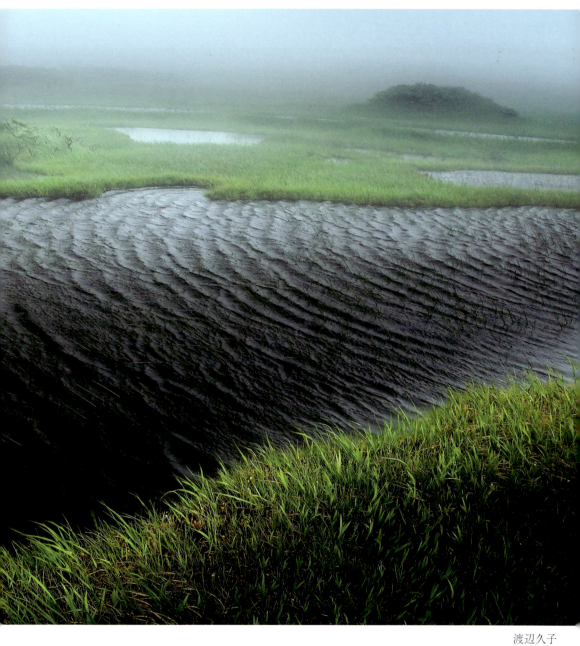

渡辺久子

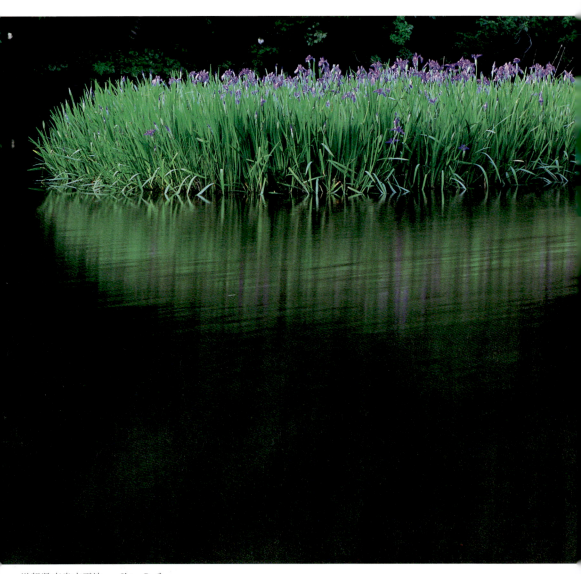

滋賀県高島市平池　　Shiga Pref.

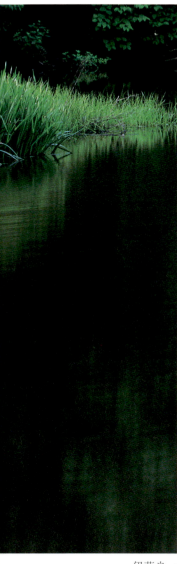

伊藤良一

手のとどく
水際うれし
かきつばた

宇多都

to my delight,
irises are reachable
on the waterside

Utanoichi

宇多都 (うたのいち) ？
Utanoichi

江戸時代中期の伊勢の俳人。

Utanoichi was a *Haiku* poet in the middle period of the Edo era, and lived in Ise.

松風に
はらはらと飛ぶ
水馬

虚子

water striders
are jumping one by one
in the wind

Kyoshi

高浜虚子（たかはま きょし） 1874-1959
TAKAHAMA Kyoshi
（p.6 参照）

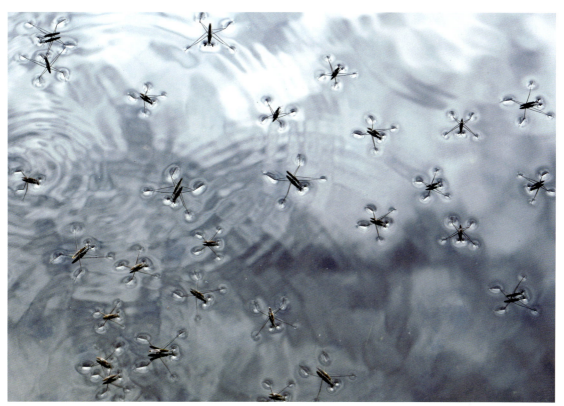

奈良県大和郡山市小南町　Nara Pref.　　　　　　　　　　　　　　　　中務敦行

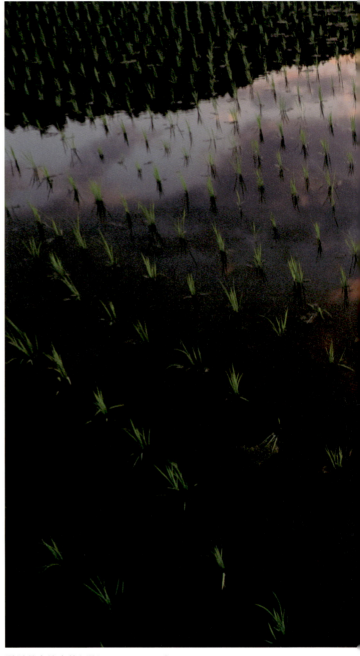

手ばなせば
夕風やどる
早苗かな

芭蕉

apart from the hand,
rice sprouts are rustling
through evening breeze

Bashō

群馬県高崎市箕郷町　Gunma Pref.

松尾芭蕉（まつお ばしょう）　1644-94
MATSUO Bashō
(p.25参照)

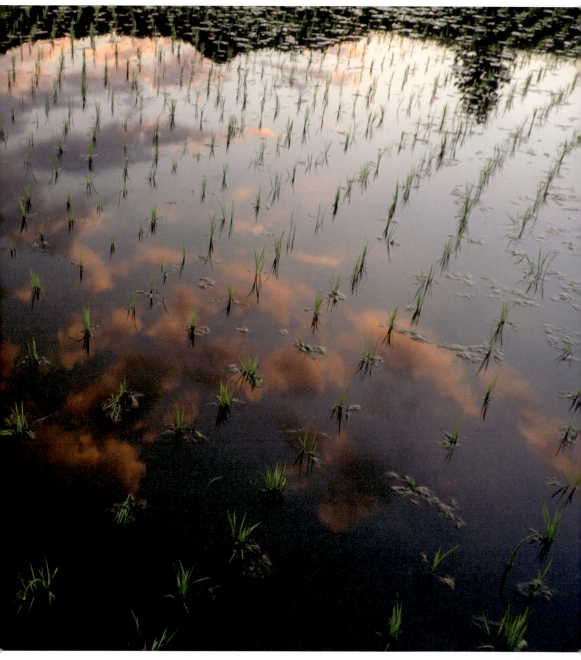

櫻井勝美

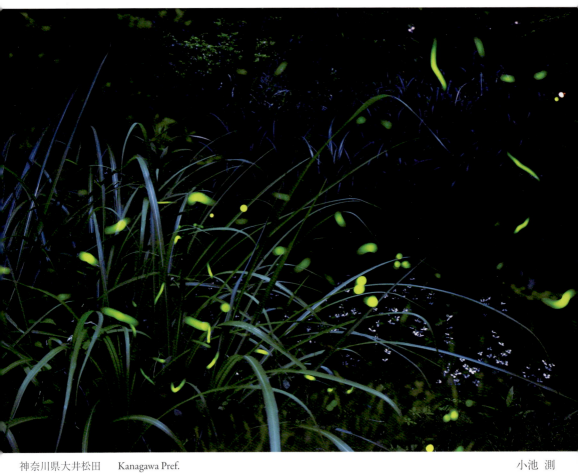

神奈川県大井松田　Kanagawa Pref.　　　　　　　小池 測

草の葉を
落るより飛ぶ
蛍かな

芭蕉

upon falling from a blade of grass,
flying up immediately-
firefly

Bashō

松尾芭蕉（まつお ばしょう）1644-94
MATSUO Bashō
(p.25 参照)

すずらんの
りりりりりりと
風に在り

草城

ding-ding
lily bells are
swinging in the wind

Sōjō

日野草城（ひの そうじょう） 1901-56
HINO Sōjō

東京生まれ。中学時代に前田普羅の指導を受け、才能を世に認められた。三高（京都）に入り、京大三高俳句会を復活させ、後に鈴木野風呂とともに俳句雑誌「京鹿子」を創刊した。

HINO Sōjō was born in Tokyo. In his junior high school days, he studied *Haiku* under MAEDA Fura and his talent was known in the public. Sōjō entered Third High School (now Kyoto University in Kyoto), restarted "Kyō-dai San-kō Haiku-kai (Haiku gathering)," and started a *Haiku* magazine "Kyōganoko."

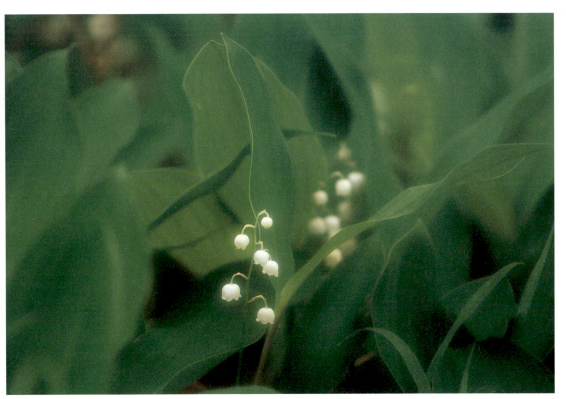

山梨県笛吹市　　Yamanashi Pref.　　　　　　　　　　　　　　　勝又れい子

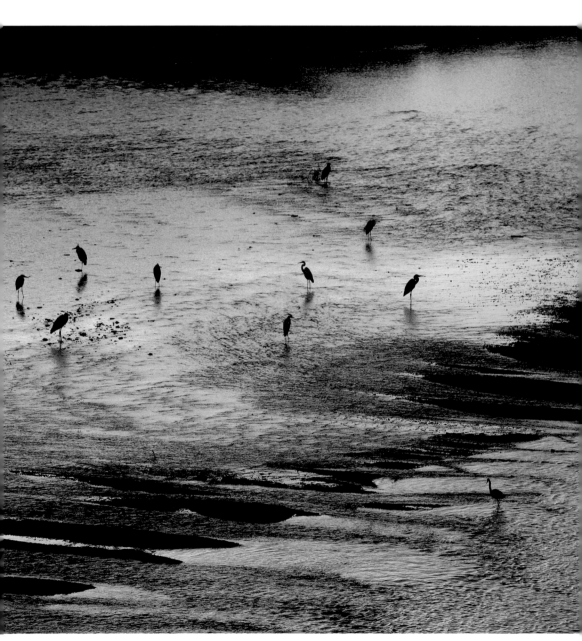

滋賀県高島市安曇川町　Shiga Pref.

与謝蕪村（よさ ぶそん） 1716-83
YOSA Buson
(p.29参照)

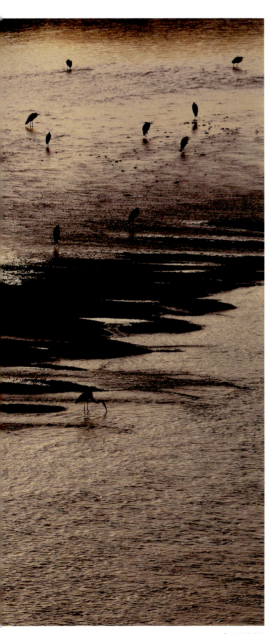

内田雅裕

evening breeze
blowing against leg of gray herons
on the water

Buson

夕風や
水青鷺の
脛をうつ

蕪村

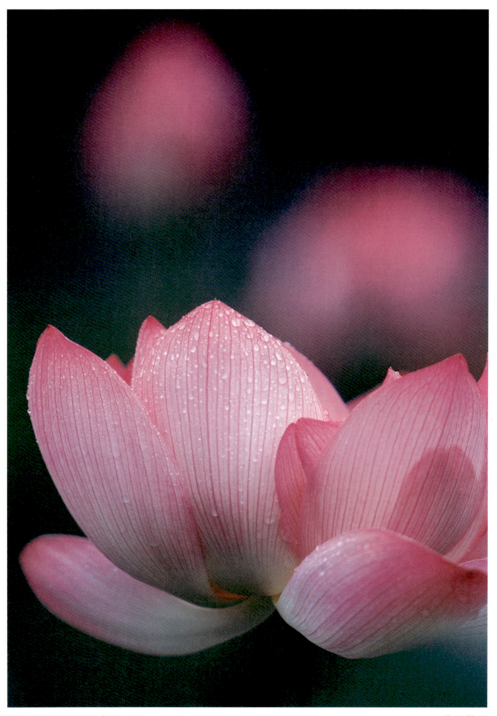

京都府亀岡市馬路町大池　　Kyoto Pref.　　　　　藤原昌平

at dawn
raindrops are falling down
on lotus flower

Kyoshi

黎明の
雨はらはらと
蓮の花

虚子

高浜虚子（たかはま きょし） 1874-1959
TAKAHAMA Kyoshi
(p.6 参照)

浮草や
蜘蛛渡りゐて
水平

鬼城

flat water surface
after spider crossing
over floating weeds

Kijō

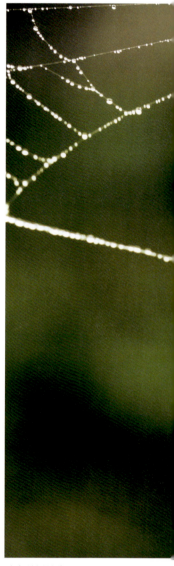

兵庫県尼崎市　Hyogo Pref.

村上鬼城 (むらかみ きじょう) 1865-1938
MURAKAMI Kijō

大正時代に活躍した俳人。東京に生まれ、父の転勤に伴い、群馬県高崎市にも住む。正岡子規と縁があり俳句を詠み、雑誌「ホトトギス」にも投句するようになり、代表的な俳人の一人となった。

MURAKAMI Kijō was a *Haiku* poet who was active in the Taisho era. He was born in Tokyo and also lived in Takasaki city, Gunma prefecture, because of his father's transfer. Kijō asked Masaoka Shiki for *Haiku*, submitted his poet to a *Haiku* magazine "Hototogisu," and became one of the famous *Haiku* poets.

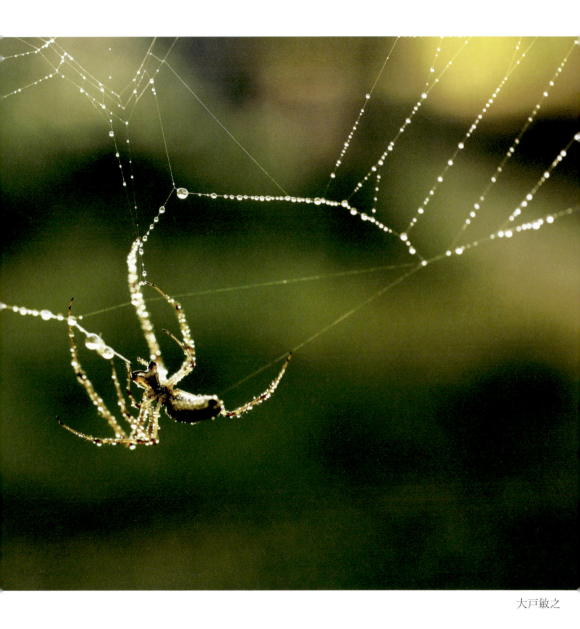

大戸敏之

水涼し
ひらひら見ゆる
魚の腹
坡仄

in cold water,
belly of flittering fish
is glittering

Hasoku

野間坡仄（のま はそく）　1724〜1801
NOMA Hasoku

江戸時代中期の伊勢の俳人。

NOMA Hasoku was a *Haiku* poet in the middle period of the Edo era, and lived in Ise.

福島県郡山市　　Fukushima Pref.　　　　　　　　　　　　　　　　青砥照男

新潟県佐渡市　Niigata Pref.

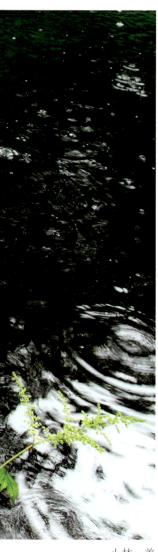

小林一美

緑わく
夏山陰の
泉かな
蓼太

full of green

a spring

in a shade of summer mountain

Ryōta

大島蓼太（おおしま りょうた）1718-87
ŌSHIMA Ryōta

江戸時代中期の俳人。信州に生まれ、のちに江戸へ出た。蕉風の俳句を学び、江戸の俳壇で活躍し、その門人は三千人に及んだという。『芭蕉句解』『俳諧十三条』などを著した。

ŌSHIMA Ryōta was a *Haiku* poet in the middle period of the Edo era. He was born in Shinshū, and then moved to Edo. He studied "Shō Fū" (Bashō style) *haiku*, was actively involved in the community of *Haiku* in Edo, and had about 3,000 pupils. Ryōta wrote "Bashōkukai" and "Haikai 13 Sections."

ひらひらと
あぐる扇や
雲の峰

芭蕉

as if
gigantic column of clouds
fluttered upward by a fan

Bashō

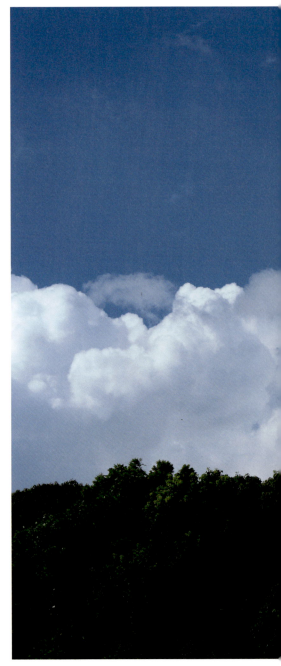

奈良県大和郡山市小南町　　Nara Pref.

松尾芭蕉（まつお ばしょう）　1644-94
MATSUO Bashō
（p.25 参照）

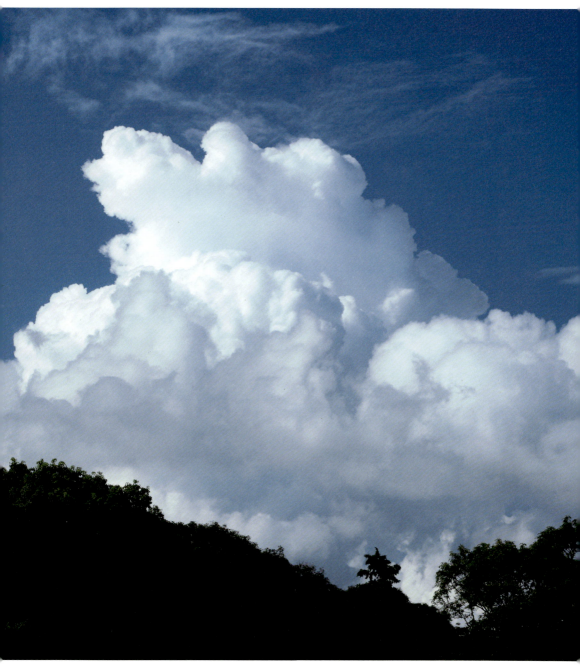

中務敦行

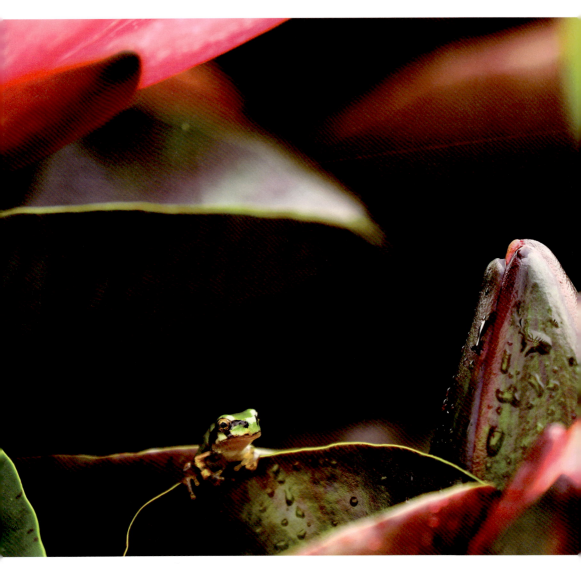

滋賀県草津市水生植物公園みずの森　　Shiga Pref.

平井眞夫

蓮の葉に
うまくのつたる
蛙哉

子規

how skillful it is!
the frog rode
on a lotus leaf

Shiki

正岡子規（まさおか しき）1867-1902
MASAOKA Shiki
(p.18参照)

暁の
紺朝顔や
星一つ
虚子

blue morning glory
at dawn-
one star
Kyoshi

高浜虚子（たかはま きょし）1874-1959
TAKAHAMA Kyoshi
（p.6 参照）

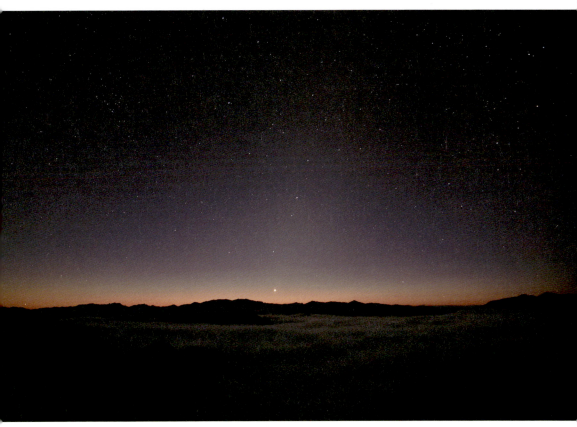

奈良県野迫川村　　Nara Pref.　　　　　　　　　　　　　　　　　小西由美

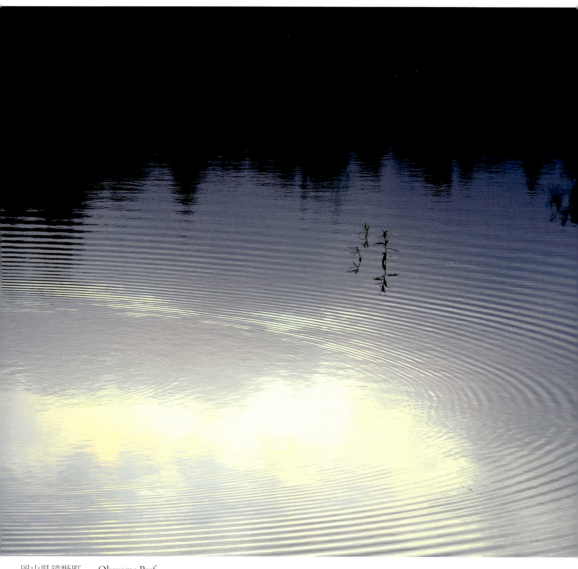

岡山県鏡野町　　Okayama Pref.

黄江康広

蜩や
山田を落つる
水の音

諷竹

evening cicada
and sound of water
falling through mountains
and fields

Fūchiku

槐本諷竹（えのもと ふうちく）　?-1712
ENOMOTO Fūchiku

江戸時代中期の俳人。大坂で活躍したと伝わる。

ENOMOTO Fūchiku was a *Haiku* poet in the middle period of the Edo era, and it is said he was active in Osaka.

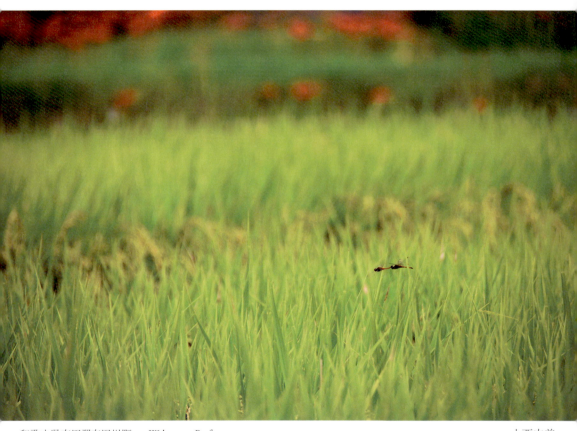

和歌山県有田郡有田川町　Wakayama Pref.　　　　　　　　　　小西由美

秋風を
あやなす物か
赤とんぼ

青蘿

how beautiful it is!
the autumn wind being decorated
with red dragonflies

Seira

松岡青蘿（まつおか せいら）　1740-91
MATSUOKA Seira

江戸時代中期の俳人。姫路藩に出仕したが、のち放浪の生活に入る。播州に戻ってからは多くの人に慕われ活躍した。

MATSUOKA Seira was a *Haiku* poet in the middle period of the Edo era. He served in Himeji-han (Himeji domain), but later, led a vagabond life. After he went back to his hometown, he was loved by many people and was actively involved as a poet.

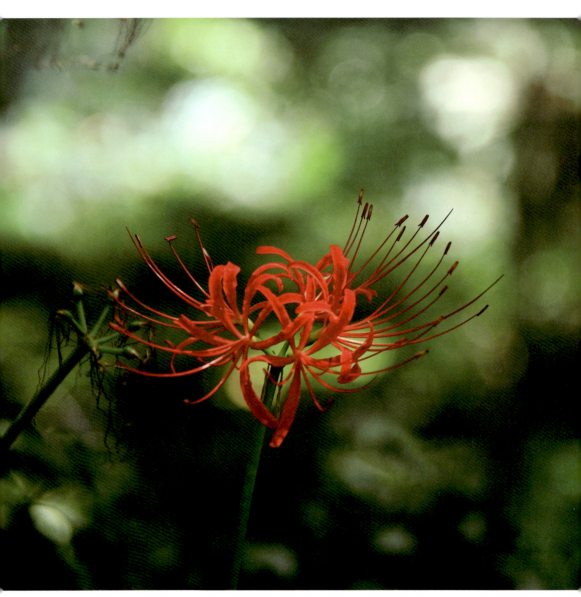

栃木県栃木市岩舟町　　Tochigi Pref.

種田山頭火（たねだ さんとうか） 1882-1940
TANEDA Santōka

大正から昭和にかけて活躍した自由俳句の俳人。
酒で身を崩し、雲水姿で旅をしながら俳句を続けた。

TANEDA Santōka was a *Haiku* poet who was active from the Taisho era to the Showa era, and was known for his free verse *Haiku*. His heavy drinking habit led to his destruction. Santōka wrote *Haiku* poems while having a walking trip as an itinerant priest.

中山賛司

藪のなか
曼珠沙華
のしづか

山頭火

among the thicket
red spider lily
standing calmly

Santōka

山は虹
いまだに湖水は
野分かな

一茶

rainbow over the mountain
but yet lake water
in the middle of the autumn tempest

Issa

滋賀県高島市　Shiga Pref.

小林一茶 (こばやし いっさ)　1763-1827
KOBAYASHI Issa

江戸時代後期の俳人。現在の長野県に生まれる。15歳の時に江戸に奉公へ出た。その俳句には滑稽さや諷刺といった特徴があるが、幼少より厳しい環境にさらされてきた生活を彷彿とさせる。

KOBAYASHI Issa, born in present Nagano prefecture, was a *Haiku* poet in the late period of the Edo era. At the age of 15, he moved to Tokyo to serve his apprenticeship. Funniness and ironicalness, which are the distinctive features of his *Haiku* poems, are associated with his severe life from his early age.

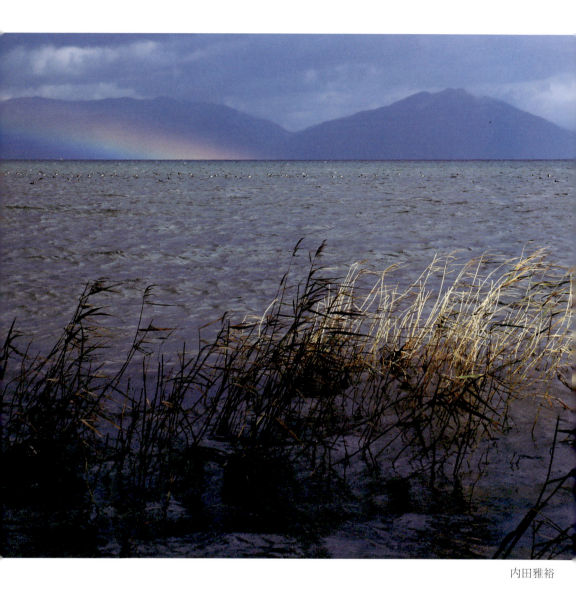

内田雅裕

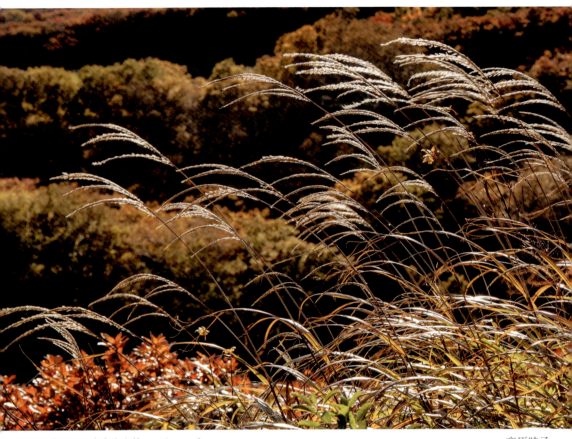

秋田県由利本庄市鳥海山麓　　Akita Pref.　　　　　　　　　　　　　　　　高原時子

枯れかれて光をはなつ尾花かな
几薫

withered away,
pampas grasses
emitting light

Kitō

高井几薫 (たかい きとう) 1741-89
TAKAI Kitō

江戸時代中期の俳人。与謝蕪村に師事した。晩年は京阪神を転々とし、最後は伊丹で没した。

TAKAI Kitō was a *Haiku* poet in the middle period of the Edo era. He was a disciple of YOSA Buson. Kito moved from place to place in Kansai area in his last years, and finally, he died in Itami.

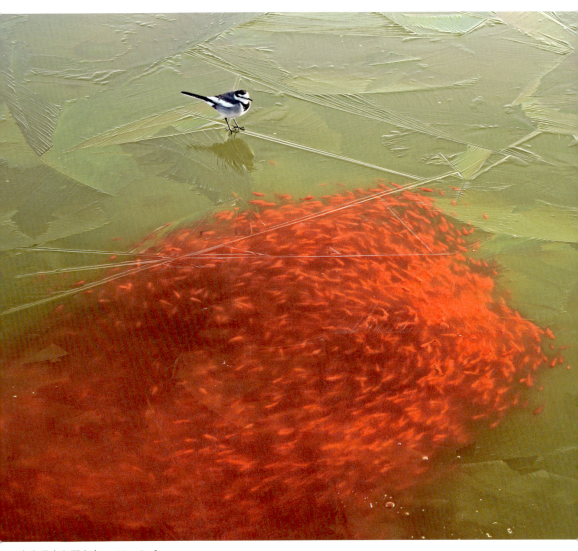

奈良県大和郡山市　Nara Pref.

中務敦行

ひよいゝと
鶺鴒ありく
岩ほ哉

子規

hopping from one to another

wagtail walking

on rocks

Shiki

正岡子規（まさおか しき）1867-1902
MASAOKA Shiki
(p.18参照)

湖も
この辺にして
鳥渡る

虚子

around there
birds are coming, and
migrate to this lake

Kyoshi

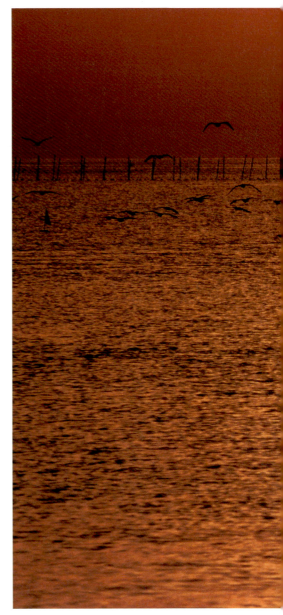

滋賀県高島市新旭町　Shiga Pref.

高浜虚子（たかはま きょし）1874-1959
TAKAHAMA Kyoshi
(p.6 参照)

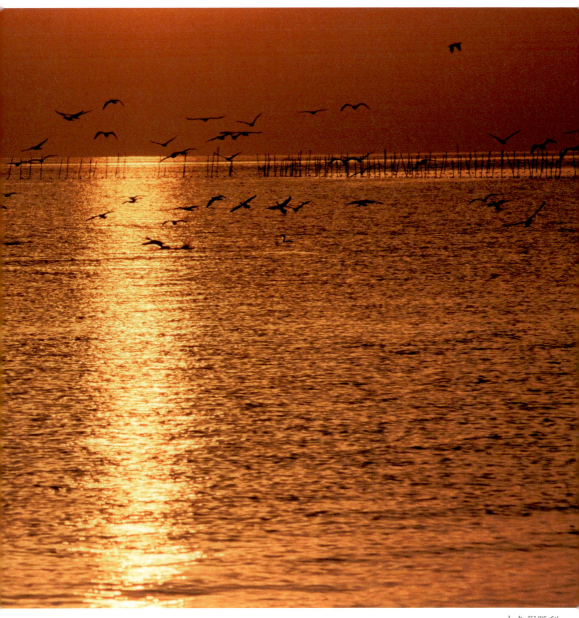

大久保勝利

長野県軽井沢町霊場池　　Nagano Pref.　　　　　　　　　　　　　　　　安藤和幸

おもひ出し
おもひ出しては
秋の雨

土芳

remember,
remember various memories
under autumn rain

Dohō

服部土芳（はっとり どほう）1657-1730
HATTORI Dohō

江戸時代前期の俳人。現在の三重県に生まれる。芭蕉と出逢い俳諧に親しむ。常に芭蕉を理解しようと努め『蕉翁句集』などを著した。

HATTORI Dohō, born in present Mie prefecture, was a *Haiku* poet in the early period of the Edo era. He met Bashō, and became intimately acquainted with *Haiku*. Dohō always tried to understand Bashō, and wrote, e.g., "Shōōkushū."

和歌山県有田郡有田川町　　Wakayama Pref.　　　　　　　　　　　　　　　　　　　　小西由美

蔦の葉の
　二枚の紅葉
客を待つ

虚子

tow colored leaves
of hedera helix
waiting for guests

Kyoshi

高浜虚子（たかはま きょし）　1874-1959
TAKAHAMA Kyoshi
（p.6参照）

直江木導 (なおえ もくどう) 1666-1723
NAOE Mokudō

江戸時代中期の俳人。近江に生まれる。芭蕉最晩年の弟子の一人。

NAOE Mokudō was a *Haiku* poet in the middle period of the Edo era. He was born in Ōmi. Mokudō was one of the disciples of Bashō in his closing years.

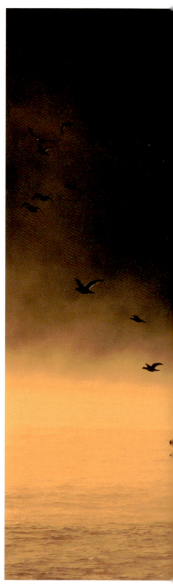

朝焼の
空こそあかき
渡り鳥

木導

It is red migratory birds
that are crossing
over sunrise glow sky

Mokudō

滋賀県高島市海津大崎　Shiga Pref.

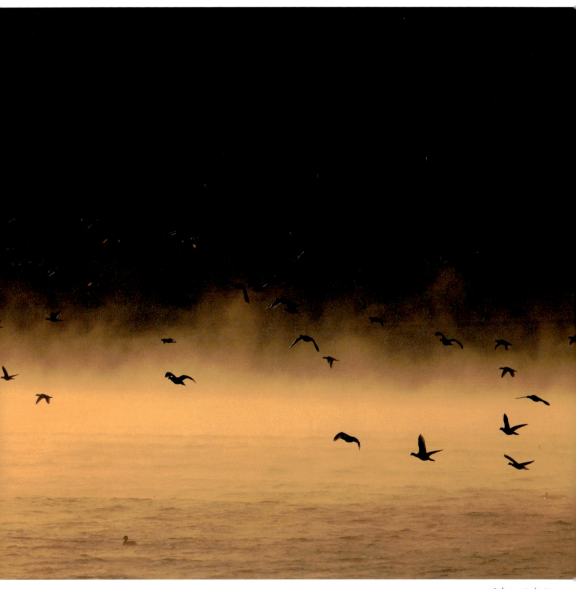

であいのりこ

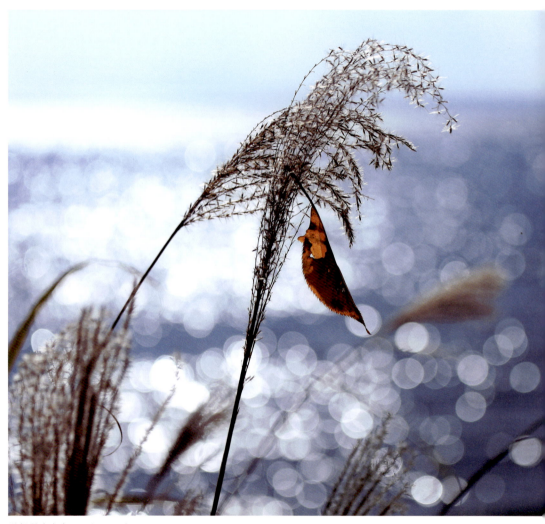

滋賀県高島市　　Shiga Pref.

内田雅裕

紅葉して
それも散行く
桜かな

蕪村

cherry blossoms have turn red,
even such turned leaves
will fall down

Buson

与謝蕪村（よさ ぶそん）　1716-83
YOSA Buson
(p.29参照)

里古りて
柿の木持たぬ
家もなし

芭蕉

my hometown is too traditional
to have no house
having no persimmon tree

Bashō

松尾芭蕉（まつお ばしょう）1644-94
MATSUO Bashō
（p.25 参照）

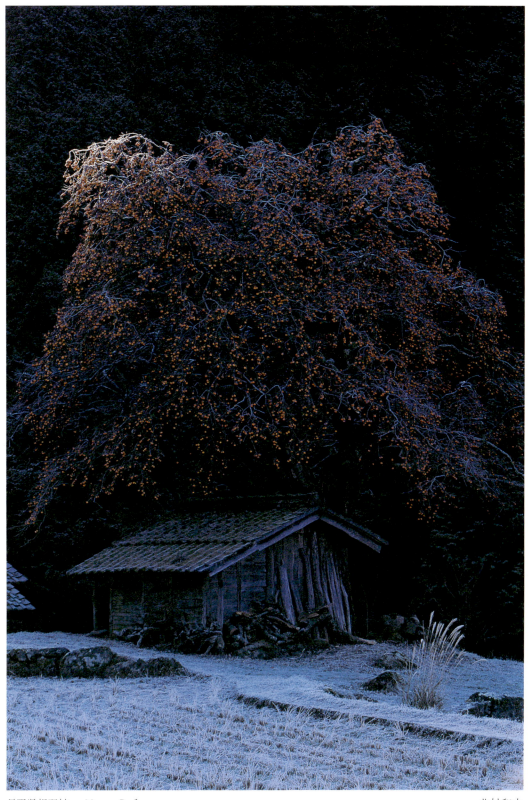

長野県根羽村　Nagano Pref.　　　　　　　　　　　　　　　　　　　北村和夫

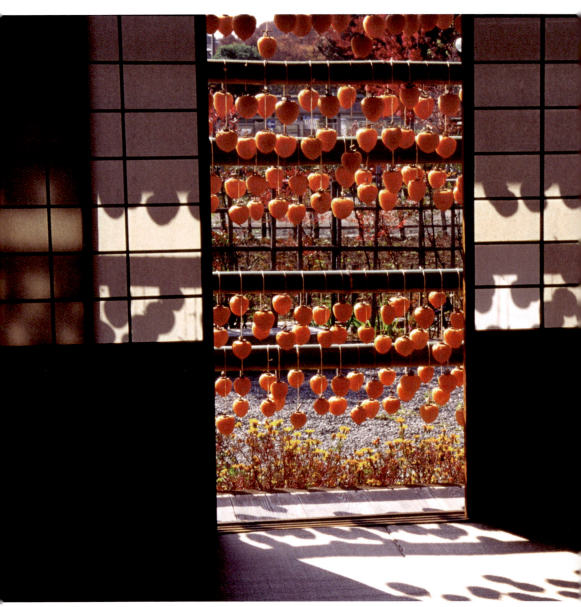

山梨県甲州市甘草屋敷　　Yamanashi Pref.

小池 測

over the neighbor's fence,
astringent persimmons hung
are looked

Shiki

垣ごしに
澁柿垂るゝ
隣かな

子規

正岡子規（まさおか しき）　1867-1902
MASAOKA Shiki
（p.18参照）

銀杏踏んで
しづかに児の
下山かな

蕪村

firmly stepping gingko
quietly climbing down the mountain
with the child on my back

Buson

与謝蕪村（よさ ぶそん） 1716-83
YOSA Buson
(p.29 参照)

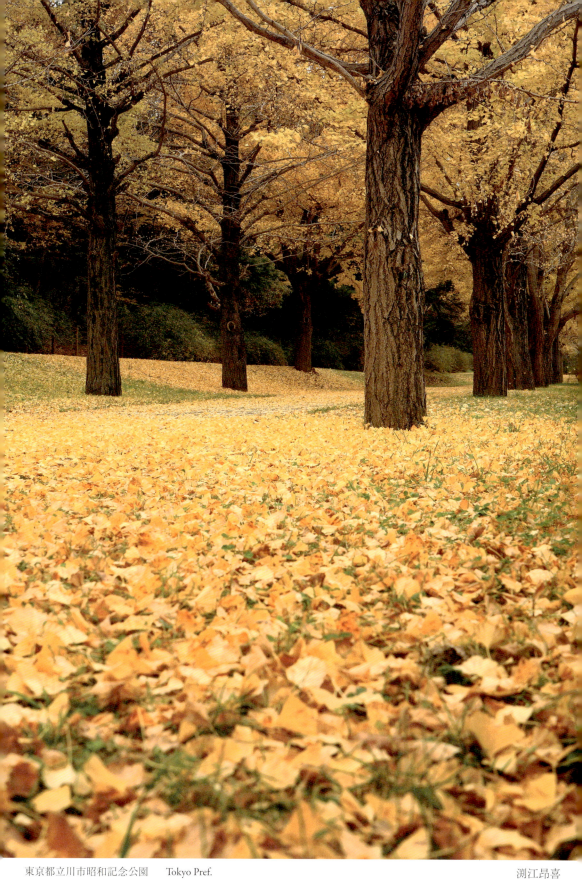

東京都立川市昭和記念公園　Tokyo Pref.　　渕江昂喜

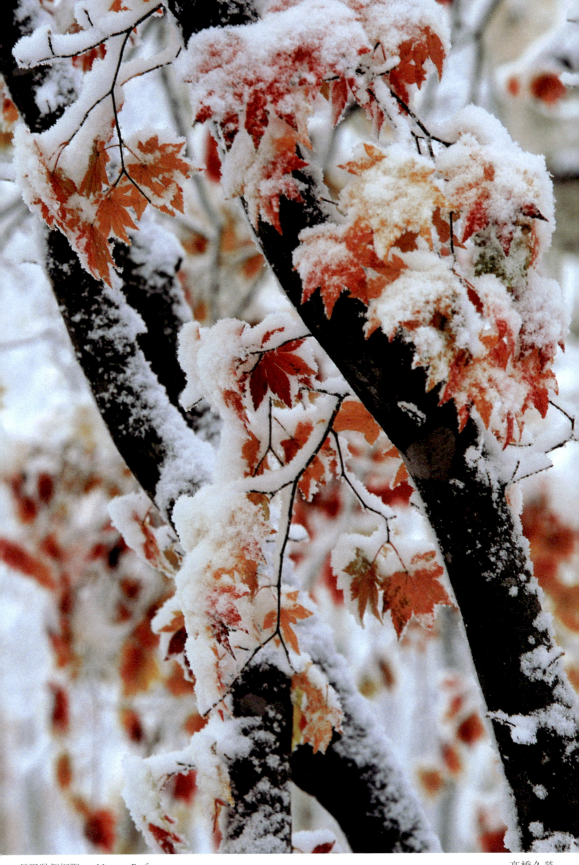

長野県飯綱町　　Nagano Pref.　　　　　　　　　　　　　　　　　　髙橋久榮

十分に
紅葉の冬と
成にけり

曉台

winter has come-
leaves have turned red
enough, satisfactorily

Kyōtai

加藤曉台（かとう きょうたい）1732-92
KATO Kyōtai

江戸時代中期の俳人。名古屋に生まれる。尾張徳川家に仕えていたが後に辞した。20歳のころから俳句を習い、芭蕉の作風を慕った。与謝蕪村とも交流があった。

KATO Kyōtai, born in Nagoya, was a *Haiku* poet in the middle period of the Edo era. He served in Owari Tokugawa family but resigned from his post later. Kyōtai started studying *Haiku* at the age of around 20, and adored Basho's style. He also had a relationship with YOSA Buson.

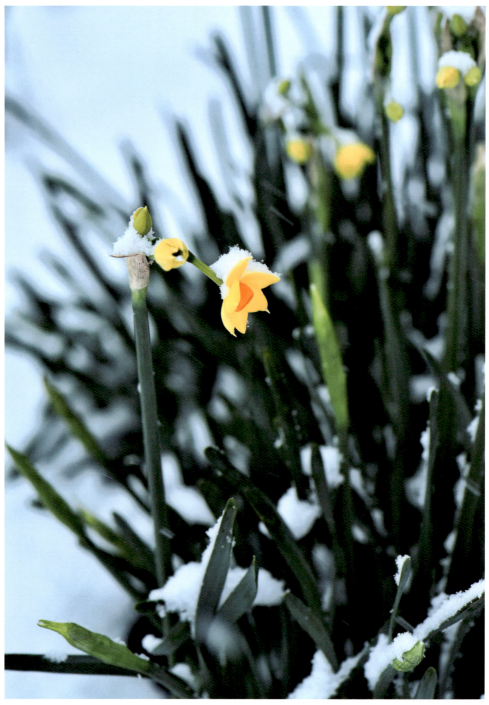

富山県魚津市　Toyama Pref.　　　　石川岩義

初雪や
水仙の葉の
撓むまで

芭蕉

first snow-
it snowed until
leaves of narcissus were weighed down

Bashō

松尾芭蕉（まつお ばしょう）1644-94
MATSUO Bashō
(p.25 参照)

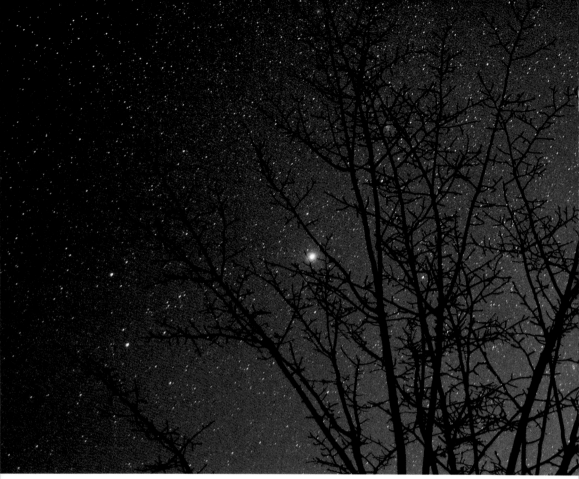

岡山県高梁市松山　　Okayama Pref.

下村槐太（しもむら かいた）　1910-66
SHIMOMURA Kaita

大阪府に生まれる。戦後大阪の俳諧をリードした。俳句雑誌「金剛」
を創刊。句集に『光背』がある。

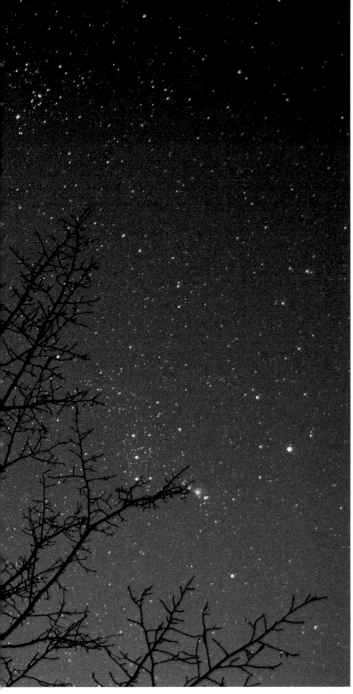

こまごまと
星をやどせる
冬木かな

槐太

here and there,
withered tree of winter
carries lots of stars

Kaita

黄江康広

SHIMOMURA Kaita was born in Osaka prefecture, and his leadership inspired the *Haiku* world in Osaka after the world war II. Kaita founded a *Haiku* magazine "Kongō." He wrote a collection of *Haiku* "Kōhai."

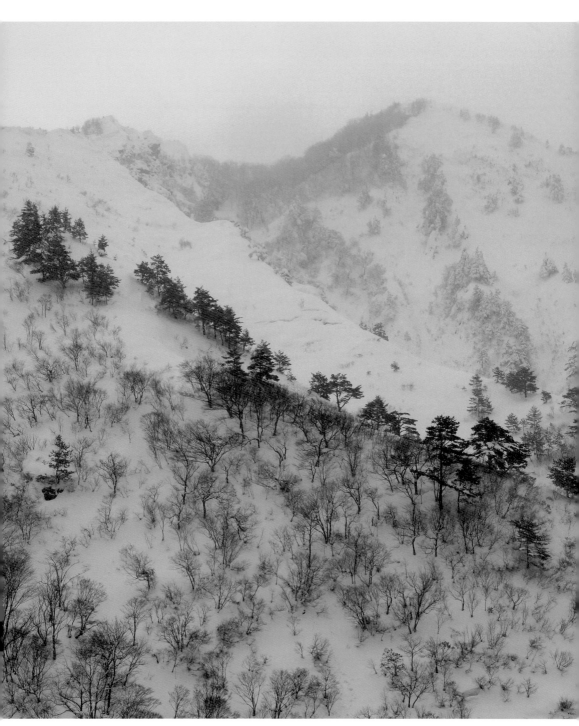

新潟県南魚沼市　　Niigata Pref.

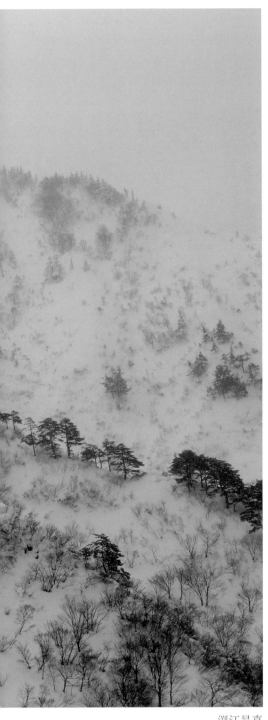

君が世や
風治りて
山ねむる

一茶

in peaceful times
storm calm down
mountains falling asleep

Issa

渕江昂喜

小林一茶（こばやし いっさ） 1763-1827
KOBAYASHI Issa
(p.82 参照)

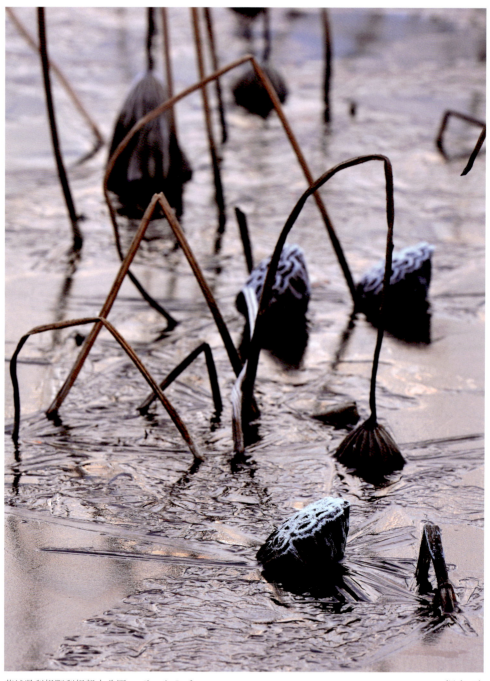

茨城県利根町利根親水公園　　Ibaraki Pref.　　　　　　　　　　　　　　桐生　武

蓮の茎
傾き合ひて
枯れにけり
泊雲

lotus stems
have withered
tilting to each other
Hakuun

西山泊雲 (にしやま はくうん)　1877-1944
NISHIYAMA Hakuun
(p.9 参照)

ともかくも
ならでや雪の
かれ尾花

芭蕉

withered pampas grasses
still standing in snow
without falling down

Bashō

岡山県鏡野町恩原湖　　Okayama Pref.

松尾芭蕉（まつお ばしょう）1644-94
MATSUO Bashō
(p.25 参照)

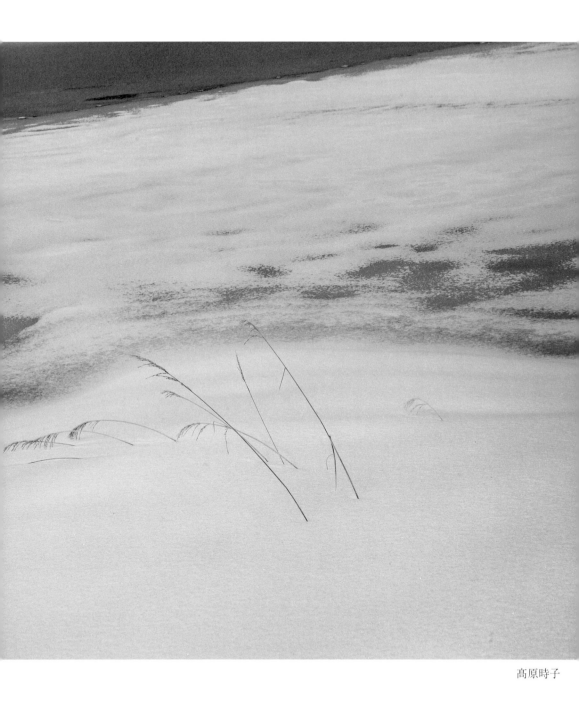

高原時子

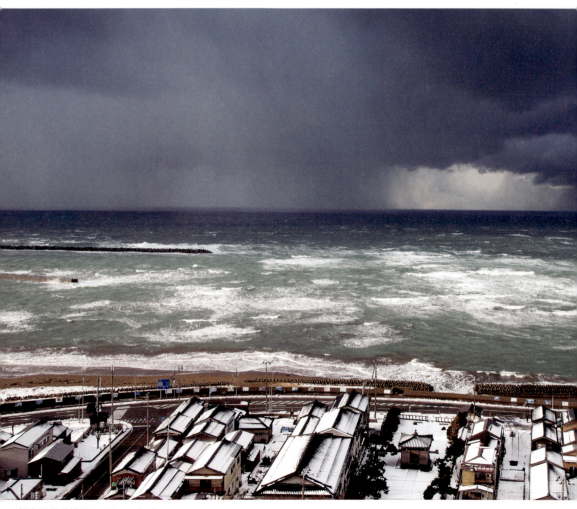

新潟県出雲崎町　　Niigata Pref.

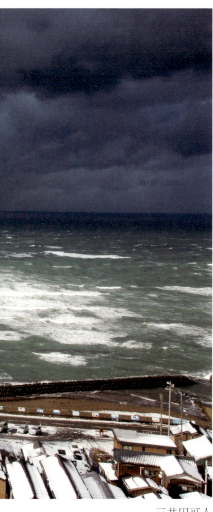

三井田可人

北風や
浪に隠るる
佐渡ヶ島

月斗

northern wind
covering Sado Island
with moving wave

Getto

青木月斗（あおき げっと）1879-1949
AOKI Getto

大正から昭和にかけて活躍した俳人。大阪府に生まれる。雑誌「ホトトギス」に投句し、正岡子規に認められ頭角を現した。俳句雑誌「同人」を創刊した。

AOKI Getto, born in Osaka prefecture, was a *Haiku* poet who was active from the Taisho era to the Showa era. He submitted his poems to "Hototogisu," and was acclaimed by MASAOKA Shiki, cutting a brilliant figure. He founded a *Haiku* magazine "Dōjin."

川中に
川一筋や
冬げしき

曉台

on the river
a river running appears-
winter landscape

Kyōtai

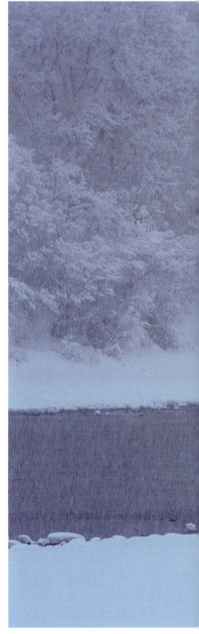

山形県戸沢村最上川　Yamagata Pref.

加藤曉台（かとう きょうたい）　1732-92
KATO Kyōtai
（p.105 参照）

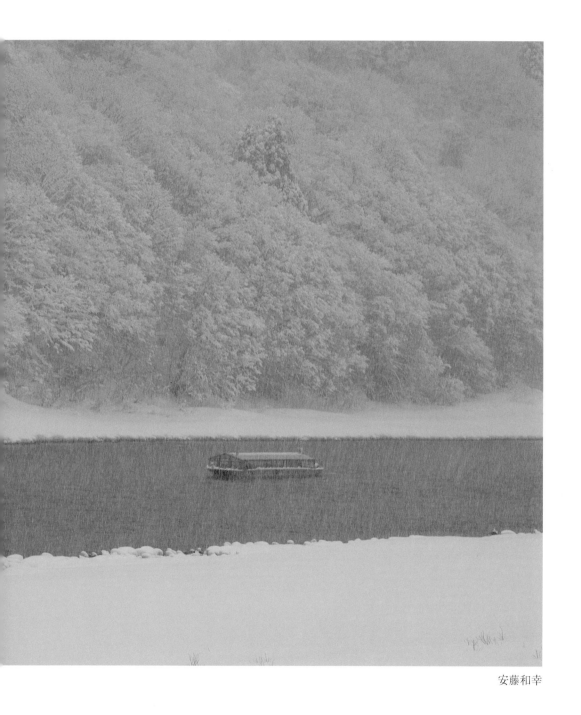

安藤和幸

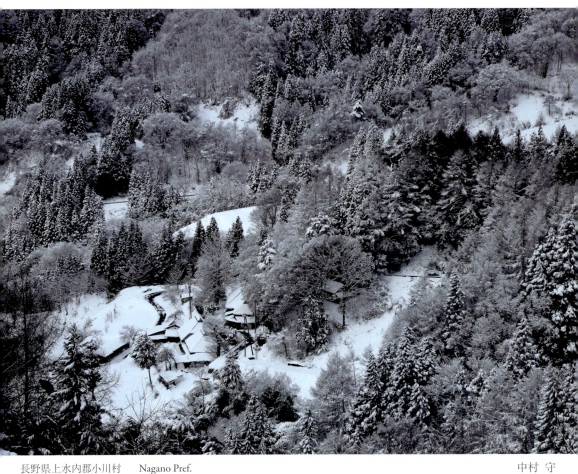

長野県上水内郡小川村　Nagano Pref.　　　　　　　　中村 守

向井去来（むかい きょらい）　1651-1704
MUKAI Kyorai

江戸時代中期の俳人。現在の大分県に生まれる。榎本其角らを介して芭蕉に入門したといわれる。京都の嵯峨に落柿舎を営んだ。

MUKAI Kyorai, born in present Ōita prefecture, was a *Haiku* poet in the middle period of the Edo era. It is said that Kyorai became a disciple of MATSUO Bashō with the aid of ENOMOTO Kikaku and other disciples. Kyorai created a hut called "Rakushisha Hut" at Saga of Kyoto.

絵の中に
居るや山家の
雪げしき

去来

the snowscape

in the mountain villa looks like

as if you were in a picture

Kyorai

長橋の
　行方かくす
　　吹雪かな

太祇

a long bridge
is now disappearing
in the snowstorm

Taigi

炭太祇 (たん たいぎ) 1709-71
TAN Taigi

江戸時代中期の俳人。江戸に生まれる。九州を訪れたのち、京にとどまり、島原に於いて不夜庵を営んだ。

TAN Taigi, born in Edo, was a *Haiku* poet in the middle period of the Edo era. After traveling to Kyūshū area, Tangi stayed in Kyoto, and then, created a hut called "Fuyaan hut" at Simabara of Kyoto.

奈良県川上村井光　　Nara Pref.

西村忠夫

リスト

頁	俳句	俳人	撮影者	撮影地
4	梅一輪いちりんほどの暖かさ	嵐雪	中島修一	神奈川県湯河原町幕山公園
6	紅梅の莟は固し言はず	虚子	黄江康広	岡山県高梁市
8	早春の流水早し猫柳	泊雲	山本 一	和歌山県新宮市西高田
10	春いまだ田毎の雪間々々かな	白雄	小鳥勝平	岐阜県高山市上切町
12	枯枝に初春の雨玉圓か	虚子	藤原昌平	滋賀県高島市朽木
14	野を焼くや棚曇りして二三日	花蓑	中村隆是	千葉県鴨川市大山千枚田
16	春雪のしばらく降るや海の上	普羅	植村 功	宮城県名取市閖上
18	湖青し雪の山々鳥帰る	子規	上村輝子	滋賀県長浜市湖北町
20	芽を吹きて柳もつるること多し	虚子	江田弘良	岡山県岡山市北区御津中牧
22	富士薄く雲より上に霞みたり	子規	中村 守	山梨県山中湖村高指山
24	さまざまの事おもひ出す櫻かな	芭蕉	櫻井勝美	群馬県東吾妻郡岡崎榛名神社
26	しばらくは花の上なる月夜かな	芭蕉	柴﨑久樹	京都府京都市
28	さびしさに花さきぬめり山ざくら	蕪村	柏尾浩司	奈良県宇陀郡曽爾村
30	うつくしい夢見直すや花の春	千代女	鶴谷典子	東京都新宿御苑
32	下からも見上げて居るや花吹雪	泊月	小池 測	群馬県妙義山
34	大峯やよしのの奥の花の果て	曾良	石原裕治	奈良県吉野山
36	散る桜残る桜も散る桜	良寛	橋本友男	新潟県南魚沼市巻機山
38	苗代の水田に晝の雲動く	肋骨	山本正二郎	兵庫県香美町
40	まざまざと夢の逃げゆく若葉かな	寺田寅彦	勝又れい子	長野県佐久穂町
42	春日野や若紫のそうがのこ	季吟	宮﨑寿一郎	奈良県奈良公園
44	戻りては灯で見る庵のぼたんかな	千代女	安藤和幸	神奈川県松田町延命寺
46	心ここになきかなかぬか時鳥	井原西鶴	片島史朗	岐阜県揖斐川町徳山湖
48	をちこちに瀑の音聞く若ばかな	蕪村	渡辺久子	山形県鶴岡市月山
50	手のとどく水際うれしかきつばた	宇多都	伊藤良一	滋賀県高島市平池
52	松風にはらはらと飛ぶ水馬	虚子	中務敦行	奈良県大和郡山市小南町
54	手ばなせば夕風やどる早苗かな	芭蕉	櫻井勝美	群馬県高崎市箕郷町
56	草の葉を落るより飛ぶ蛍かな	芭蕉	小池 測	神奈川県大井松田
58	すずらんのりりりりりりと風に在り	草城	勝又れい子	山梨県笛吹市
60	夕風や水青鷺の脛をうつ	蕪村	内田雅裕	滋賀県高島市安曇川町
62	黎明の雨はらはらと蓮の花	虚子	藤原昌平	京都府亀岡市馬路町大池

頁	俳句	俳人	撮影者	撮影地
64	浮草や蜘蛛渡りゐて水平	鬼城	大戸敏之	兵庫県尼崎市
66	水涼しひらひら見ゆる魚の腹	坡仄	青砥照男	福島県郡山市
68	緑わく夏山陰の泉かな	蓼太	小林一美	新潟県佐渡市
70	ひらひらとあぐる扇や雲の峰	芭蕉	中務敦行	奈良県大和郡山市小南町
72	蓮の葉にうまくのつたる蛙哉	子規	平井眞夫	滋賀県草津市水生植物公園みずの森
74	暁の紺朝顔や星一つ	虚子	小西由美	奈良県野迫川村
76	蜩や山田を落つる水の音	諷竹	黄江康広	岡山県鏡野町
78	秋風をあやなす物か赤とんぼ	青蘿	小西由美	和歌山県有田郡有田川町
80	藪のなか曼珠沙華のしづか	山頭火	中山賛司	栃木県栃木市岩舟町
82	山は虹いまだに湖水は野分かな	一茶	内田雅裕	滋賀県高島市
84	枯れかれて光をはなつ尾花かな	几董	高原時子	秋田県由利本庄市鳥海山麓
86	ひよいゝと鶺鴒ありく岩ほ哉	子規	中務敦行	奈良県大和郡山市
88	湖もこの辺にして鳥渡る	虚子	大久保勝利	滋賀県高島市新旭町
90	おもひ出しおもひ出しては秋の雨	土芳	安藤和幸	長野県軽井沢町霊場池
92	蔦の葉の二枚の紅葉客を待つ	虚子	小西由美	和歌山県有田郡有田川町
94	朝焼の空こそあかき渡り鳥	木導	であいのりこ	滋賀県高島市海津大崎
96	紅葉してそれも散行く桜かな	蕪村	内田雅裕	滋賀県高島市
98	里古りて柿の木持たぬ家もなし	芭蕉	北村和夫	長野県根羽村
100	垣ごしに澀柿垂るゝ隣かな	子規	小池　測	山梨県甲州市甘草屋敷
102	銀杏踏んでしづかに兒の下山かな	蕪村	渕江昂喜	東京都立川市昭和記念公園
104	十分に紅葉の冬と成にけり	暁台	髙橋久榮	長野県飯綱町
106	初雪や水仙の葉の撓むまで	芭蕉	石川岩義	富山県魚津市
108	こまごまと星をやどせる冬木かな	槐太	黄江康広	岡山県高梁市松山
110	君が世や風治りて山ねむる	一茶	渕江昂喜	新潟県南魚沼市
112	蓮の茎傾き合ひて枯れにけり	泊雲	桐生　武	茨城県利根町利根親水公園
114	ともかくもならでや雪のかれ尾花	芭蕉	高原時子	岡山県鏡野町恩原湖
116	北風や浪に隠るる佐渡ヶ島	月斗	三井田可人	新潟県出雲崎町
118	川中に川一筋や冬げしき	暁台	安藤和幸	山形県戸沢村最上川
120	絵の中に居るや山家の雪げしき	去来	中村　守	長野県上水内郡小川村
122	長橋の行方かくす吹雪かな	太祇	西村忠夫	奈良県川上村井光

日本風景写真協会の紹介

当会は風景の撮影を主とする者の集まりで、写真の創作技術等の向上、会員相互の交流を図り社会貢献することを目的としている。
協会創立は平成14年で会員数は1400名を超える。
概ね各都道府県に45支部があり、事業として年2回協会本部主催の撮影会・講演会(名誉会員・指導会員による)や会員相互の情報交換、作品紹介等の情報誌の発行及び支部単位での撮影会・例会・作品展等を開催している。
名誉会員に白簱史朗・丹地敏明、指導会員に川隅功・小松ひとみ・髙橋毅・辰野清・田中達也・中西敏貴・野呂希一・萩原史郎・増井治・山本一が名を連ね、指導に当たっている。

編集後記

　先人の詠まれた言葉だけで表現する風景に、その意味を壊すことなく添える日本風景写真協会会員の豊かな感性あふれる写真との融合の一冊となりました。季節の移ろいや、はぐくむ命の息吹、それらを美しく愛おしいと思う日本文化を感じ取っていただければ幸いです。
　出版にあたり多大なご協力をいただきました、光村推古書院様、ニューカラー印刷様、関係者の皆様、会員の皆様に深く感謝し御礼を申し上げます。

であいのりこ

Afterword

　This book is a fusion between imagined scenery, *Haiku*, expressed with only words composed by our ancestors and photographs taken by members of Japan Nature Scenery Photograph Association. The photographs are full of sensitivity, and are added to the imagined scenery without destroying the meaning of the words. I hope that readers of this book will feel seasonal transitions, breath of nurtured lives, and Japanese culture in which such things are considered as beautiful and lovely.
　For publishing this book, I am most grateful to Mitsumura Suiko Shoin Publishing Co., Ltd, NEW COLOR PHOTOGRAPHIC PRINTING CO., LTD, other persons concerned, and the members of Japan Nature Scenery Photograph Association.

DEAI Noriko

日本風景写真協会

俳句の風景
Photographs of Imagined HAIKU Landscapes

平成30年12月7日初版一刷発行

写　真　日本風景写真協会会員

企　画
制　作　日本風景写真協会
　　　　〒600-8216
　　　　京都市下京区東塩小路町607番地10号　サンプレ京都ビル3階
　　　　PHONE 075(746)4578　FAX 075(746)4568
　　　　http://www.jnp21.jp/

発行者　合田有作

発行所　光村推古書院株式会社
　　　　〒604-8257
　　　　京都市中京区堀川通三条下ル橋浦町217番地2
　　　　PHONE 075(251)2888　FAX 075(251)2881
　　　　http://www.mitsumura-suiko.co.jp

印　刷　ニューカラー写真印刷株式会社

©2018 Japan Nature Scenery Photograph Association　Printed in Japan
ISBN978-4-8381-9839-9

本書に掲載した写真・文章の無断転載・複写を禁じます。
本書のコピー、スキャン、デジタル化等の無断複製は著作権法上での例外を除き禁じられて
います。本書を代行業者等の第三者に依頼してスキャンやデジタル化することはたとえ個人
や家庭内での利用であっても一切認められておりません。
乱丁・落丁本はお取り替えいたします。

構　成：大戸　敏之
　　　　であいのりこ
　　　　山口かづ美
翻　訳：笹田　景子
　　　　（WIS知財コンシェル株式会社）
デザイン：松田　聡子
校　正：片山奈生美
進　行：山本　哲弘
印刷設計：大西　智幸
印　刷：濱岡　賢次
　　　　近藤　眞史
編　集：合田　有作